IMAGES
of America

VICTOR

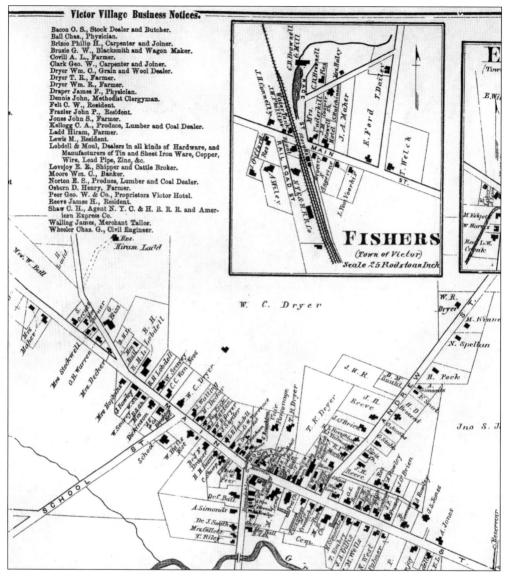

This 1874 map is of the village of Victor and the hamlet of Fishers.

On the cover: This is Main Street, Victor, around 1900. The north side of the street is newly built. Fire ravaged the former wooden buildings in 1899, and new buildings were required to be constructed of brick. (Courtesy of the Town of Victor Archives.)

IMAGES
of America

VICTOR

Babette Mann Huber

ARCADIA
PUBLISHING

Published by Arcadia Publishing
Charleston SC, Chicago IL, Portsmouth NH, San Francisco CA

Printed in the United States of America

Library of Congress Catalog Card Number: 2006928535

For all general information contact Arcadia Publishing at:
Telephone 843-853-2070
Fax 843-853-0044
E-mail sales@arcadiapublishing.com
For customer service and orders:
Toll-Free 1-888-313-2665

Visit us on the Internet at www.arcadiapublishing.com

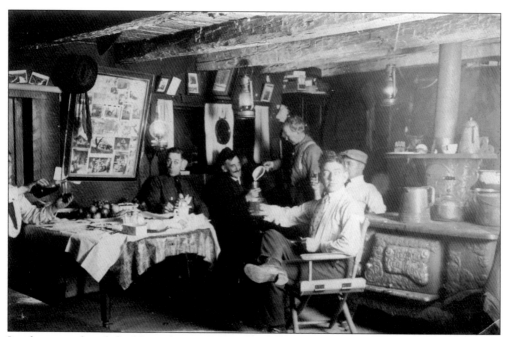

Inside a now demolished log cabin on Benson Road, built about 1803, sit Jim Riley, "General" Ulysses Grant Hunt, and other men.

CONTENTS

ACKNOWLEDGMENTS

Thank you to all of the people of Victor who enthusiastically shared their knowledge of Victor's history. Special thanks go to those who helped me with various aspects of this book, Betty Barry, Chuck Callari, John Freund, Eldred Sale, Bonnie Waters, and Pat and Greg Welch. I want to especially thank Lois Smith Bumpus for her inspiration and for the wonderful visits that I had with her as she shared the breadth and depth of her knowledge of Victor's history.

INTRODUCTION

The original settlers to the town of Victor, New York, were the Seneca Indians. During the 17th century, they established one of their principal villages at what is now Ganondagan, on top of Boughton Hill. When French traders wanted sole control of the fur trade, they attacked the Senecas in 1687 and the Senecas were defeated. The land lay fallow for over 100 years. Ganondagan is now owned by the state of New York. It is New York State's only Native American historic site devoted solely to the history and culture of the Haudenosaunee, or People of the Longhouse.

After the American Revolution, when western New York had been made safe for settlement, Victor was acquired from the Phelps and Gorham Purchase. Township No. 11, Range No. 4—a six-mile-square piece of land—was purchased for 20¢ an acre by Enos Boughton in 1788. In 1790, members of the Boughton family left Stockbridge, Massachusetts, to begin settlement at the former site of the Seneca capital on top of Boughton Hill. Other settlers from New England followed, and agriculture became the town's most important industry. The town was originally part of Bloomfield and was known as Boughtontown because of the original family who bought the township of Victor.

The town of Victor was set apart from Bloomfield and officially established by an act of the state legislature of New York in 1812. It was named Victor in honor of Claudius Victor Boughton, who distinguished himself in the War of 1812.

Transportation and land helped Victor become prosperous. As an agrarian area, Victor's hamlet of Fishers became an important potato producer in the late 19th century, one farmer growing as much as 10,000 bushels a year. With the Auburn and Rochester Railroad, the New York Central and the Lehigh Valley Railroad, Victorites became large produce dealers. As a result of glacial activity, Victor is home to unique cobblestone architecture. One building, the Fishers Railroad Pumphouse, built in 1845, is believed to be the second-oldest surviving railroad structure in the United States. In the mid-20th century, New York governor Thomas E. Dewey broke ground in Victor for the western part of the New York State Thruway.

Some notable individuals—some prominent and some not so prominent—were connected to Victor. Buffalo Bill Cody, while visiting a friend in Victor, showed his shooting skills by shooting a potato off a man's head with a shotgun. Theodore Roosevelt gave a speech from the platform of his railroad car at the Victor station in 1898. James Hard, who was born in Victor, became the nation's last surviving combat veteran of the Civil War, dying at the age of 111. Victor's most illustrious citizen was Fred M. Locke, who invented new improvements of the design of porcelain insulators in the early 20th century, when electricity was quickly spreading throughout the United States.

Photographs from the Town of Victor Archives, the Victor Historical Society, the Ontario County Historical Society, and Ganondagan, as well as some from private collections, help the reader learn what makes Victor's history unique. Included are several photographs that have never before been printed. Hopefully this pictorial recording of Victor's historical past will be memorable for schoolchildren as well as adults.

One

BEGINNINGS

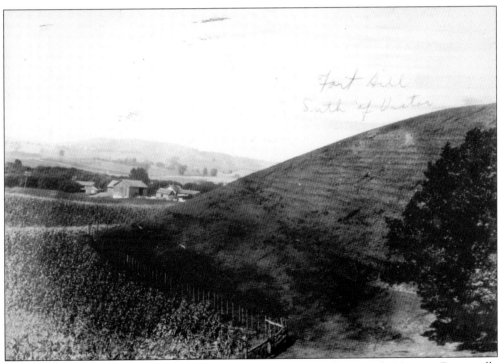

Fort Hill was part of the Seneca capital at Ganondagan. The French Marquis Denonville destroyed Fort Hill as well as Ganondagan in 1687 in the quest for control of the beaver trade. The fort, with stores of corn and the palisade surrounding it, was burned by the French. It was never rebuilt. Fort Hill is part of the Ganondagan State Historic Site today.

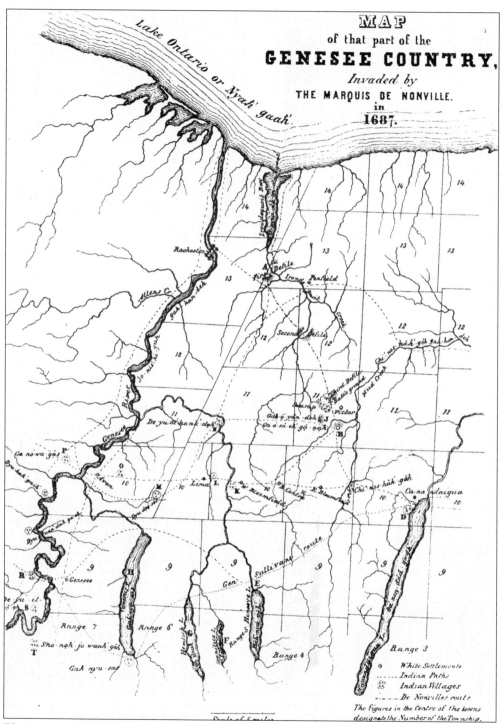

The Marquis Denonville's march for control of the Seneca beaver trade is depicted on this map. His army of French regulars, American Indian allies, and Canadian woodsmen-militiamen landed at the end of Irondequoit Bay and marched south to Victor, Honeoye Falls, Bloomfield, and Lima to destroy the Seneca villages.

HAUDENOSAUNEE

PEOPLE OF THE LONGHOUSE

The Seneca call themselves Onondowahgah, People of the Great Hill. They are the western-most people of the Haudenosaunee, known today as the Six Nations Iroquois. Haudeno-saunee means, "People who Build Houses," and the term has come to designate the League of the Iroquois. When this confederacy was founded, the Seneca were entitled Keepers of the Western Door.

The Longhouse was not simply a dwelling. It was an idea:

Hereabouts are five nations, each with its own council fire, yet they shall live together as one household in peace. They shall be the Kanonsionni, the Longhouse. They shall have one mind and live under one law. Thinking shall replace killing, and there shall be one commonwealth.

With these words the founder of the con-federacy, who is known as the Peacemaker, addressed Jikonhsaseh, the Mother of Nations, the first woman to embrace the Great Law of Peace.

This engraving represents the People of the Longhouse, the Haudenosaunee. The Seneca call themselves Onondowahgah, "People of the Great Hill." They are the westernmost people of the Haudenosaunee, known today as the Six Nations Iroquois. The longhouse was not simply a dwelling, it was an idea—five nations, each with its own council fire, yet they would live together as one household in peace.

GAYANESSHA?GOWA

THE GREAT LAW OF PEACE

The Gayanessha?gowa, or Great Law, is the founding tradition of the League of the Haudenosaunee. The Great Law originated sometime between the tenth century, A.D., and the early sixteenth century. The League of the Haudenosaunee continues to meet under its rules at Onondaga near Syracuse, New York.

The founders of the League believed in-justice must be abolished before peace could exist. Peace was not viewed simply as the absence of conflict but the product of sincere and informed negotiations which sought justice as a precondition to true peace.

Seneca oral tradition relates that Hiawatha and the Peacemaker, founders of the League, met Jikonhsaseh at her home near here. She offered advice which enabled them to per-suade the opposition, led by Onondaga chief Tadodaho, to join the movement for confedera-tion.

The Gayanessha'gowa, or "Great Law," is the founding tradition of the League of the Haudenosaunee. The founders of the league believed injustice must be abolished before peace could exist. Seneca oral tradition relates that Hiawatha and the Peacemaker, founders of the league, met Jikonhsaseh at her home near here. She offered advice, which enabled them to persuade the opposition led by Onondaga chief Tadodaho to join the movement for confederation.

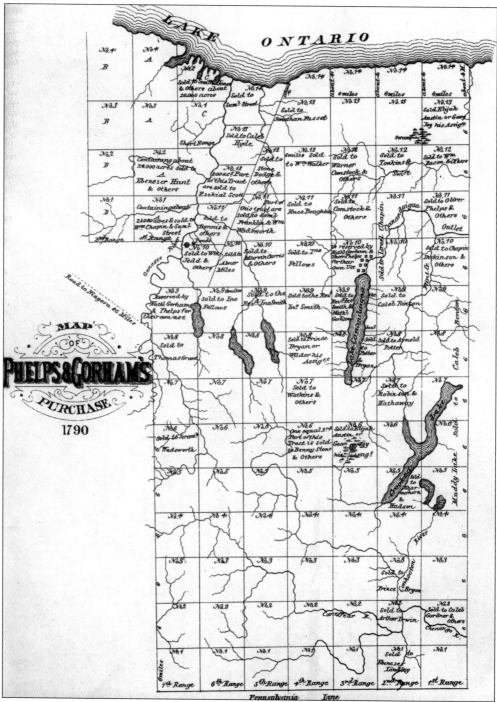

Oliver Phelps and Nathanial Gorham, investors from New England, purchased a substantial tract of land from Massachusetts in 1788. The territory went north from Lake Ontario, south to the Pennsylvania line, west to the Genesee River, and east to the Preemption Line. The land was then divided in townships of six miles square that were sold.

Enos Boughton of Stockbridge, Massachusetts, purchased Township 11, Range 4 (later to be known as the town of Victor) for his father, Hezekiah, in 1788. It was bought from the Phelps and Gorham Purchase. An assistant surveyor for Phelps and Gorham, Boughton saw how rich the fertile land of the Genesee Valley was. The purchase price of the six-mile-square parcel was 20¢ an acre. The Boughton family began its settlement at the top of Boughton Hill in 1790 and named the town Boughtontown.

Jared and Olive Stone Boughton (shown here), with their children, Selleck, not quite two years old, and Melania, four months old, became the first family to settle in Victor in 1790. They traveled from Stockbridge, Massachusetts, to Victor between February 19 and March 7, 1790. Traveling over frozen ground on a sleigh was easier than using a wagon over rutted or nonexistent roads. Olive Stone Boughton was the first white woman to come to the town.

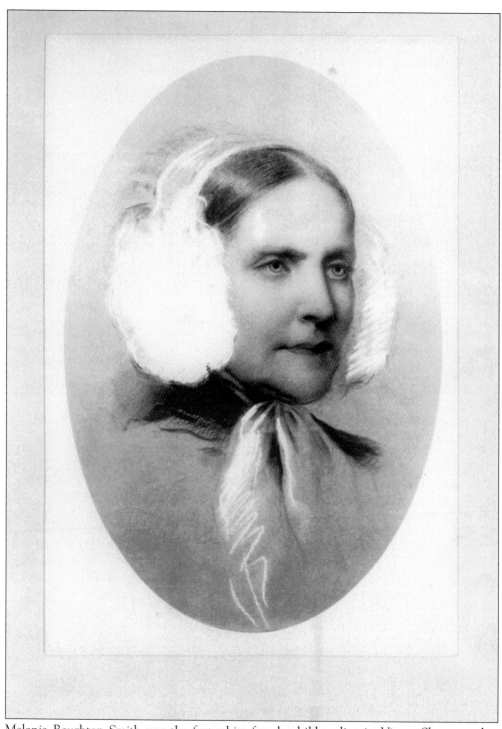

Melania Boughton Smith was the first white female child to live in Victor. She wrote her recollections of her life on the top of Boughton Hill—Boughtontown—in a diary. "We were a neighborhood of brothers, sisters, parents, nephews, nieces, uncles, aunts and cousins. In all things we were a united band of relatives."

14

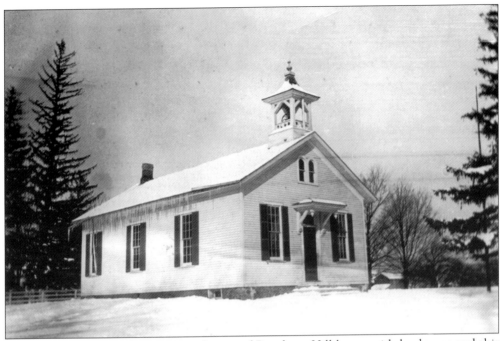

The settlement of Boughtontown at the top of Boughton Hill began with log homes and this school, shown here in deep snow in 1918. The Boughton Hill School, built in 1802, was Victor's first schoolhouse. When the Boughton family arrived from Stockbridge, Massachusetts, and settled on Boughton Hill, a plan was made by Hezekiah Boughton to set aside land for a school, cemetery, and town square. The school was demolished in the 1940s after a central school was built on High Street. Below is a picture of some students posing in front of the Boughton Hill School about 1910.

The Wilmarth Tavern on Boughton Hill was built sometime between 1810 and 1816 by Ezra Wilmarth. Ezra Wilmarth, or Uncle Ezra, as he was familiarly called, came from Stockbridge, Massachusetts (as did the Boughtons). This Federal-style brick home was originally a tavern from 1816 to 1824 and served the stagecoach line that ran from Albany through Canandaigua to Rochester and Buffalo. Local recruits for the War of 1812 practiced their drills on the common in front of the inn.

The Boughton Hill Cemetery is the oldest cemetery in the town of Victor. Among those who are buried there are Hezekiah Boughton, original buyer of the town of Victor, who died in 1798; and Olive Boughton, the first white woman to live in Victor, who died in 1849.

Two

THE VILLAGE

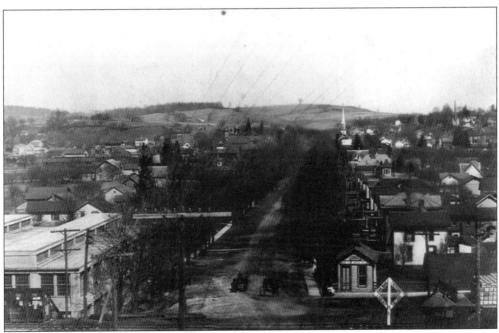

The village of Victor was incorporated in 1879. The first meeting was on December 31, 1879. James Walling was elected village president, and F. W. Edmonds was elected village clerk. Two of the village's first resolutions were for the streetlamps to be put into condition for immediate use and for the railroad company to comply with the law as to the obstruction of trains across the streets of the village. The residents had complained that they had to wait too long, so the ordinance allowed a five-minute limit.

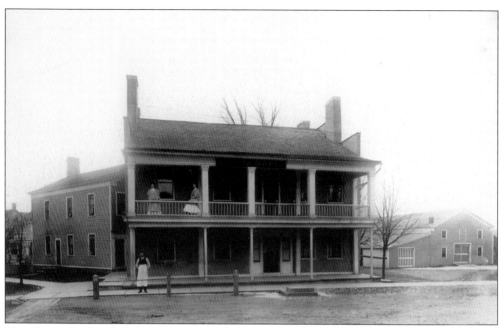

The Victor Hotel, a famed inn of stagecoach days, was built in 1818–1819 by Rufus Dryer. Dryer had contracted Seth Berray to construct the building for a bushel of wheat a day. The brick for the structure was made in the ravine north of the Victor Town Hall. The grand two-story brick building, with a chimney on each of its corners, was opened on Christmas Day 1819. An elaborate ball, open to the public, was held with music furnished by a brass band from Springwater. Dryer died the following year, but his wife kept up the hotel for two years before renting it to John M. Hughes. A frame addition was built on later, and the upper floor was used as a dance hall until 1857. It was then remodeled for sleeping rooms. The Victor Post Office was housed in the Victor Hotel when William C. Dryer was postmaster between 1837 and 1843. The photograph below depicts the Victor Hotel barn.

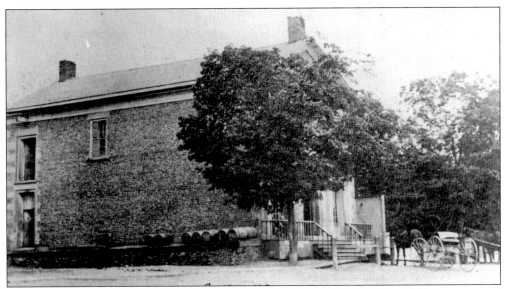

William Gallup's old store, which was built in 1835 by Thomas Embry, was a cobblestone general store located on the corner of Moore Avenue and East Main Street. William Gallup bought the store in 1857, and it was later known as the Gallup Store. Previous to buying the store, Gallup was a teacher for three years in the Camp District and then on Boughton Hill for two years. In 1884, William B. Gallup was taken into partnership with his father. On January 14, 1893, a fire started in the basement and ignited several kegs of gunpowder and quantities of kerosene and some fireworks. The fire completely destroyed the building.

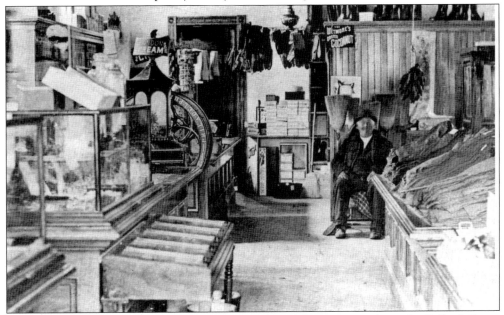

Seneca Boughton is seen here pausing from his job as delivery wagon driver for Gallup's Store. Boughton worked in his early life as a farmer, and it is reported that he bought and shipped the first carload of potatoes sent from Victor over the New York Central Railroad. In his later years, he began working for William Gallup in the general store and was called Uncle Seneca by the children.

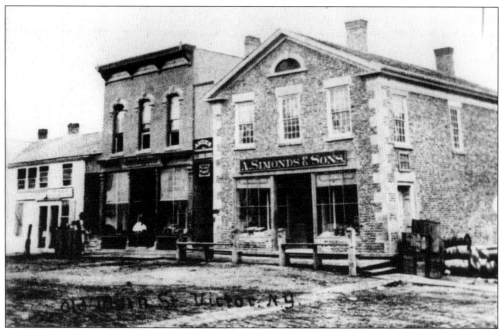

This photograph shows Old Main Street in Victor about 1860, before the building of the Walling Block. On the south side of East Main Street, a row of wooden buildings is shown next to the cobblestone general store, Simonds and Sons. James Walling began to demolish the framed buildings and build his single, two-story, brick Walling Block in 1874.

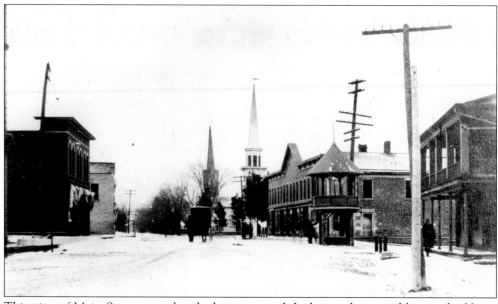

This view of Main Street was taken looking eastward. It shows a horse and buggy, the Victor Hotel, Simonds Store, the Walling Block, the Presbyterian and Methodist churches, and the Gallup Store. The Walling Block was built in 1874 and housed many small businesses. It was a mini-mall of sorts. An addition was put on in 1881. Fred Walling, proprietor of the Walling Block, was the village's first president (now called mayor) when the village was incorporated in 1879.

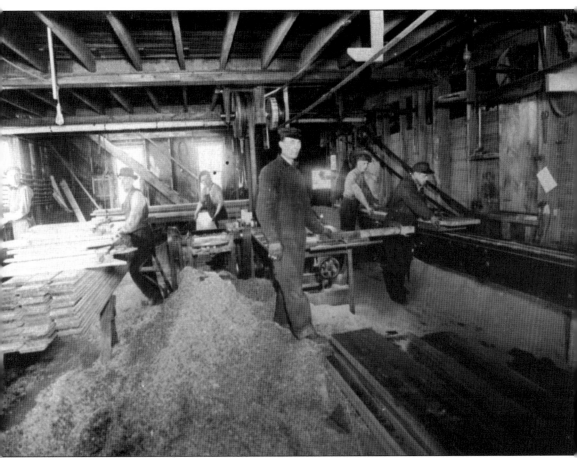

This interior of the Wilcox-Johnson Tank Company shows, from left to right, Bill Ewer, Charles Wilcox, Milton Wilcox, John Brady, Clarence Potter, and Hi Wilcox. The Wilcox-Johnson Tank Company began in 1870, when Charles Ezra Wilcox saw a need for a better way of obtaining water for the growing agricultural community. He first started making the tanks by hand on the floor of his father's barn. The demand for his wood tanks grew (not only for water but for acid, chemicals, vinegar, pickles, and spray) so much that a new factory was built in 1912. The repeal of Prohibition made the demand for tanks increase even more. Retail lumber and hardware divisions were soon added, and during the 1940s, the Bartholomew Lumber and Coal Company was added. The company was renamed Victor Coal and Lumber Company and was moved across the Lehigh tracks. It is now the oldest continuing business in Victor.

The F. E. Cobb Drug Store is pictured before the fire of 1898. Also shown is Miss Haney's bakery.

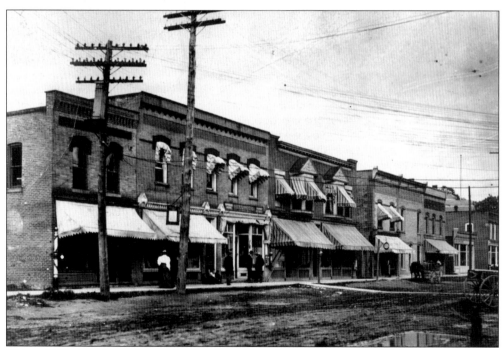

This *c.* 1900 view shows the north side of east Main Street, a muddy road. After the fire of 1898, all new buildings in the business district were required to be built of brick. Note the wooden plank sidewalks and street crosswalks.

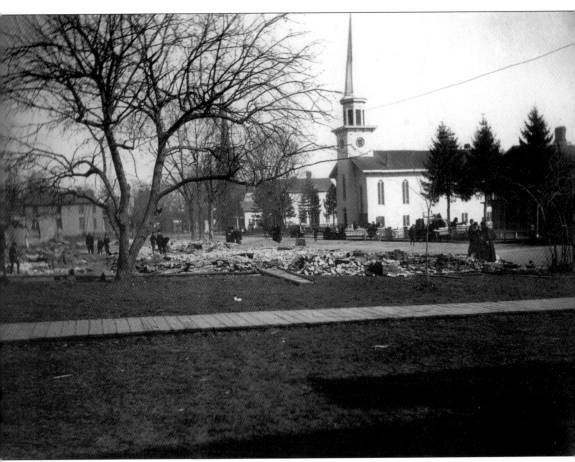

The Victor fire of April 10, 1898, is shown in this view, looking eastward from Gallup's Store. About 9:00 p.m., as churchgoers were leaving church on Easter Sunday, a large explosion was heard. The Opera House Hotel was ablaze at the very center of the north side of East Main Street. Church bells rang to alert the townspeople of the fire. The wooden buildings just burst into flames simultaneously. With no formal fire department, 11 businesses, two homes, and two barns burned that night. Lost in the fire were a hotel owned by John Ryan, the harness shop of Charles Jacobs, a general implement store operated by a Mr. Bement, the undertaking rooms of Ziba C. Curtice, the laundry owned by George R. Brown, the millinery shop of a Mrs. Warren and a Mrs. Goodnow, and the jewelry store of a Mr. Paddelford. The last stores to burn were F. E. Cobb's drugstore, Frank Pimm's barbershop, Miss Haney's bakery, and Henehan's boot and repair shop. The houses and barns occupied by the families of John Murphy and John J. Cardy burned, as did the Gallup barn.

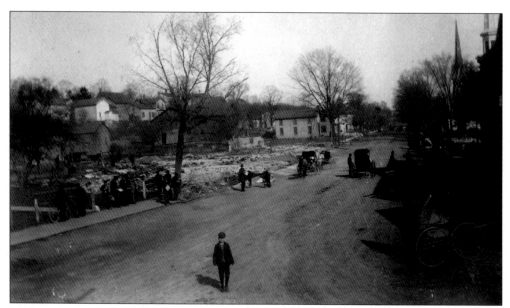

Looking eastward across the street, this picture shows the fire damage of April 10, 1898, from the vantage of the Simonds Cobblestone Store. The fire destroyed all the buildings on the north side of East Main Street from Moore Avenue to Church Street.

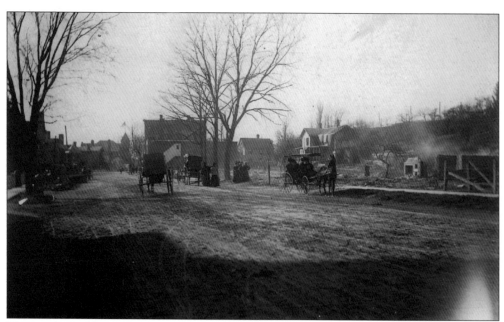

The Jacobs Building, where the fire of 1898 started, was a three-story building and the largest business block in Victor. The building was 44 feet across and 60 feet deep. It was designed by Albert Jacobs. The first two floors contained businesses, and the third floor was designed for use as a public hall. Operas, dances, meetings, and other events were held there. This picture was taken before the town had built a town hall.

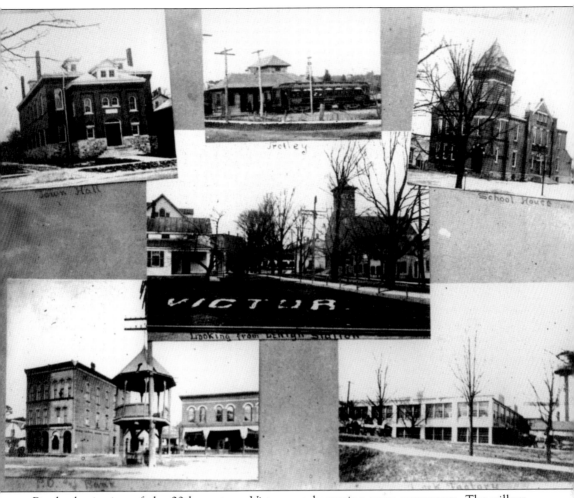

By the beginning of the 20th century, Victor was becoming more prosperous. The village landmarks shown are, from left to right, (above) the new town hall on Main Street, the Rochester and Eastern Rapid Railway Depot on Maple Avenue, and the Union School on the corner of School Street and West Main Street; (middle) Maple Avenue; (below) the Four Corners in the middle of the village of Victor with its bandstand and the only factory at the time, Locke Insulator Company.

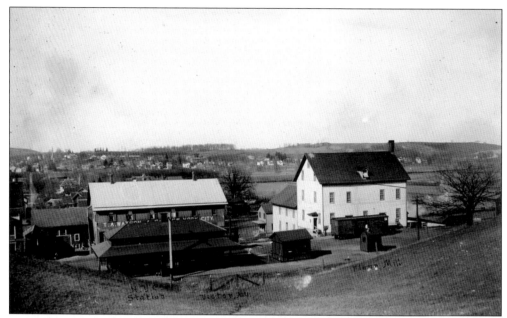

The Victor Flour Mill, on the right, was the original building erected in 1876 by Amos Scramling. It was powered by steam. By the late 1800s, E. S. Berry became the owner, and in 1890, Fred Locke of Locke Insulators hooked up a generator to the steam engine at the mill. In 1911, the Victor Milling Company purchased the building and did extensive renovations. On the eve of its opening in February 1912, the building was entirely destroyed by fire.

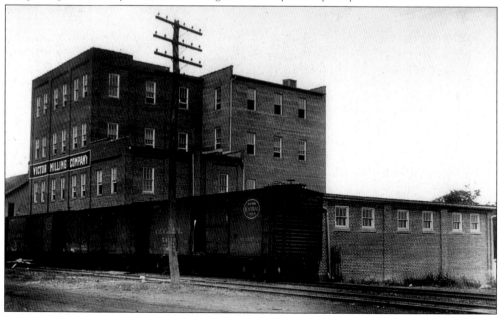

The Victor Milling Company, pictured with a New York Central train in the forefront, began operating in this brick building in October 1912. The milling company's "King Victor" bread was noted as a superior brand as well as its pastry flour—Ontario Pride. The mill was sold to the Pittsford Milling Company in 1921 and became Victor Flour Mills, Inc. On January 28, 1937, the building burned to the ground.

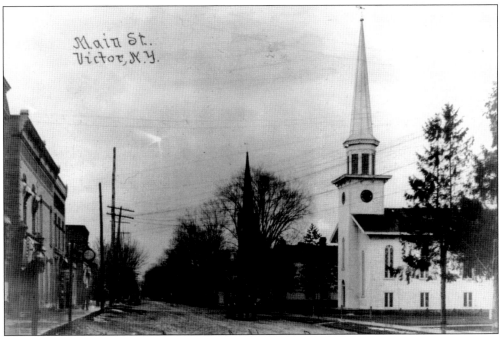

In 1882, the first telephone lines reached Victor. In this 1906 picture of Main Street, the skyscape is already showing multiple telephone and electric lines.

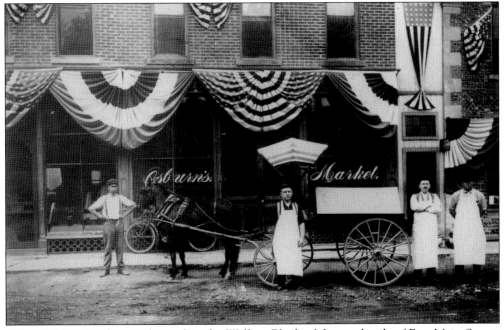

Osburn's Meat Market was located in the Walling Block of the south side of East Main Street. L. C. Osburn sold his interest in 1924.

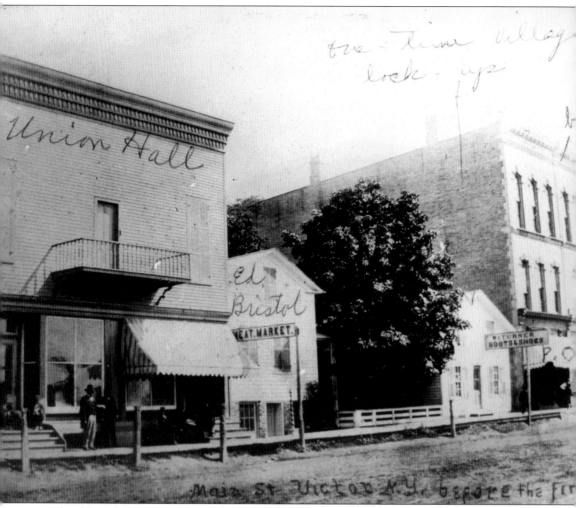

This view of Main Street dates from before the fire of 1899. It shows the Union Hall, Ed Bristol's Meat Market, W. Turner Boots and Shoes, the one-time village lockup, and the bank building. The fire of 1899 erupted on October 15 in a shed behind the offices of the *Victor Herald*. Since no fire department was organized yet, the alarm was rung from the Universalist Church on Maple Avenue and E. Monks rode through the streets on his horse shouting the alarm. The wooden buildings of the Union Hall, the boardinghouse of Mary McCrone, the residences of E. C. Bristol and Mrs. Lucy, and the H. E. Cornford harness shop were lost. Saved were the three-story brick bank building, the residence of George Bliss, and Dr. Mead's office building on Moore Avenue.

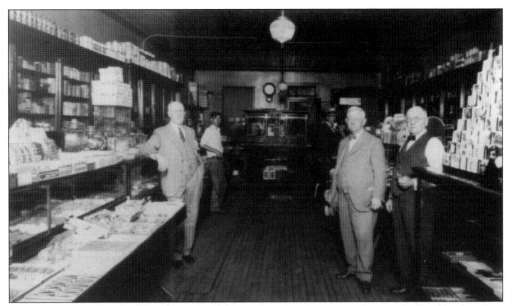

The interior of Cobb's Drug Store on East Main Street is shown here; in the foreground, from left to right, are F. E. Cobb, C. L. Brown, and M. A. Smith. Cobb had been hired by John Woolsey in 1884 to work for him for $2.50 a week. Six years later, Cobb took over the drugstore and remained in the business for almost 50 years. Charles Brown was a clerk in the drugstore and was also the town of Victor's clerk for almost 50 years before he died in 1938. Milton Smith was also a clerk for Cobb.

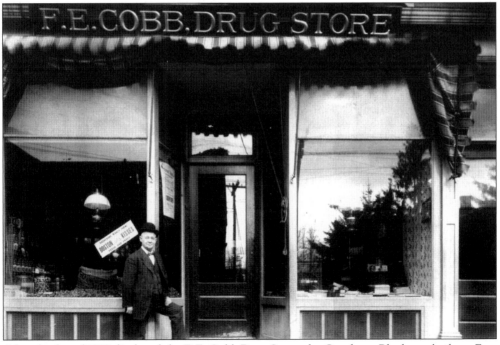

After the fire of 1898 displaced the F. E. Cobb Drug Store, the Goodnow Block was built on East Main Street and Cobb relocated there. F. E. Cobb's wife was the former Frances Goodnow. In the window is an advertisement for Boston Kisses.

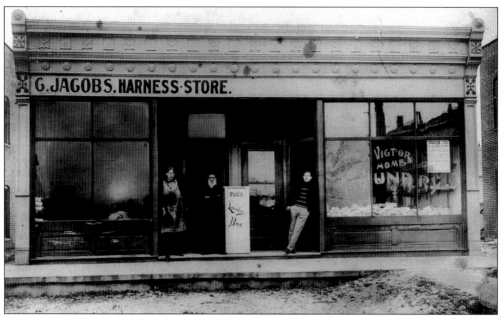

G. Jacobs Harness Store is shown in the early 1900s. The store made and repaired horse harnesses. Ovid Jacobs, pictured in the middle, was nicknamed "Obe Harness the Jacob Maker." Next-door is the Victor Home Laundry, with a laundry box between both stores. William B. Moore bought the laundry business from A. Ray Cornford in 1901 and ran it first at the Jacobs Block and then he erected a concrete, two-story building west of the fire hall on West Main Street.

This view of the growing village of Victor was taken from Webster Heights behind the buildings on the north side of West Main Street.

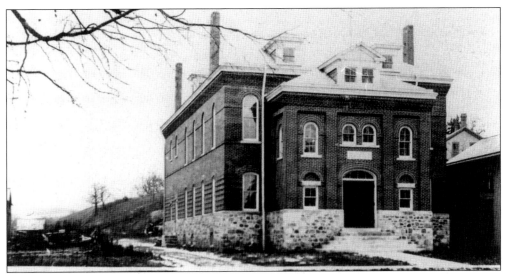

The original Victor Town Hall was built in 1900 at its present site. It was built on the "Foundry Lot" owned by William Cornford. The voters of Victor authorized the town board to spend $8,000 to erect a new town hall. On June 6, 1900, the cornerstone was laid with much ceremony. The town hall was not only used for town meetings, but for town and school basketball games, graduation ceremonies, alumni banquets, plays, dances, club meetings, and minstrel shows. The building had a kitchen and a combination of a gymnasium and auditorium as well as a jail. It burned to the ground on November 19, 1933, in a fire that started when a heating-plant smokestack overheated.

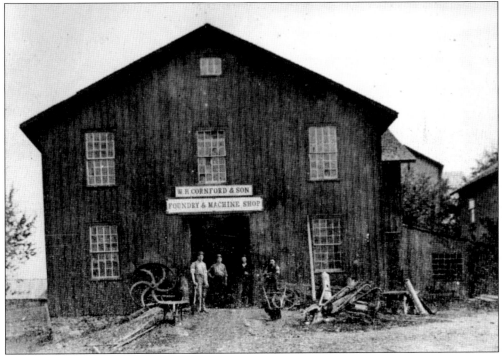

Shown is W. H. Cornford and Son Foundry and Machine Shop, 1882–1900, on the site of the present town hall.

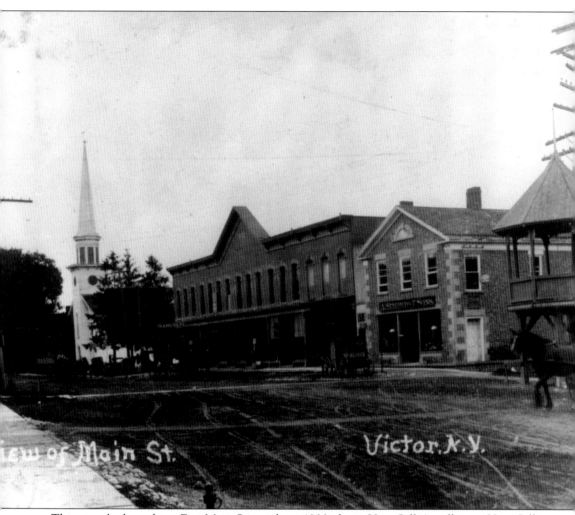

This view, looking down East Main Street about 1900, shows Hart Gillis's milk cart. Hart Gillis owned his own dairy, cooled the milk, bottled it, and sold it for 5¢ a quart and 3¢ a pint.

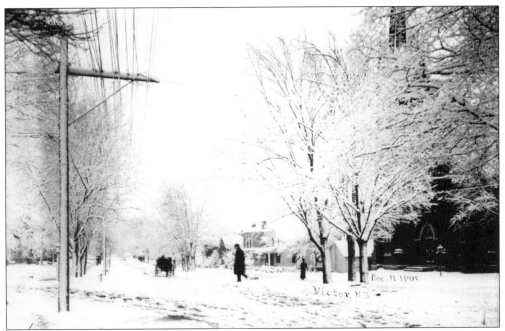

Thomas Henry, a cobbler, is shown crossing Maple Avenue on December 11, 1907.

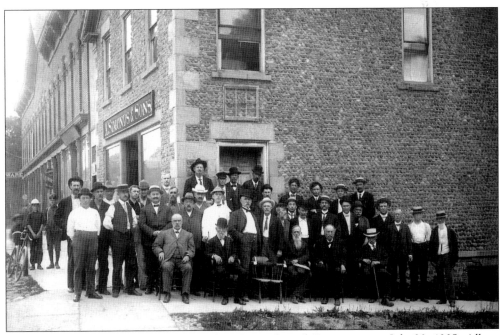

Victor businessmen are seen in front of A. Simonds and Sons store on July 20, 1905. Albert Simonds came to Victor in 1832 to work for Nathan Jenks in his cobblestone general store. Later, in 1837, Simonds became a partner. He was famous for his stovepipe hat and for whistling as he made deliveries from his store. In 1885, he retired and his sons George and C. Lewis ran the business. Other family members, Russell and Lewis, carried on the tradition until 1967, when the store closed.

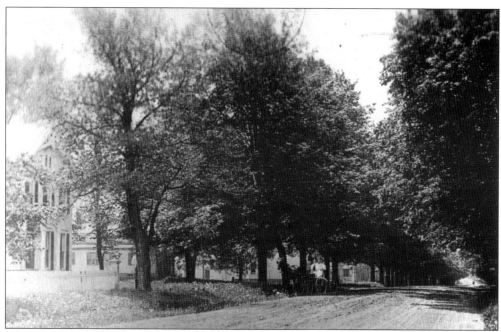

This southern view shows the glorious maple trees on Maple Avenue in the early 1900s. Maple Avenue had originally been Railroad Street until a resident of the street, Hamilton French, began planting maple trees along the road. Note the couple in the horse and buggy driving down the dirt road before the age of the horseless carriage.

Victor is written in prominent letters on Maple Avenue at the beginning of the century—long before the building of the Victor Fire Hall.

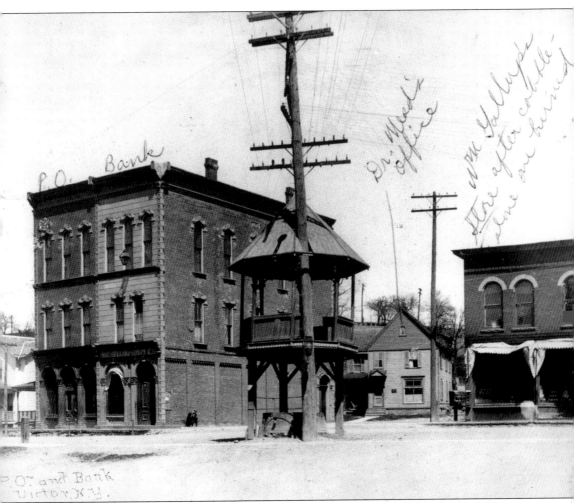

This view shows the Victor Post Office and Bank, the bandstand, Dr. Mead's office, and William Gallup's store after the cobblestone one burned. In 1872, the Bank Block, the only remaining three-story building in the village of Victor, was erected by John Moore. It was a private bank opened by Moore's brother, Billy. The third floor was to be used as a ballroom. In 1895, the post office was located in the bank building and remained there for 35 years. In December 1900, the first rural route delivery (25 miles) was started.

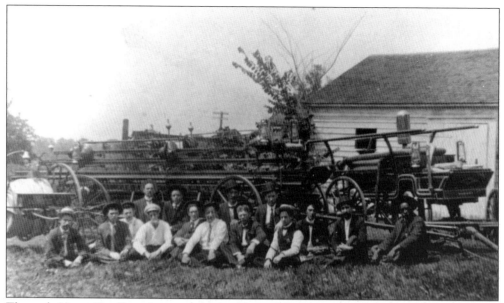

The early Victor Fire Department is depicted here. The Victor Fire Department was organized on June 8, 1904. The first meetings were held in the Gallup Block until the fire hall was built in 1910 on West Main Street. The devastating Main Street fires of 1898 and 1899 persuaded the village not only to organize a fire department but also to install a water system in 1907.

The original Victor Fire House stands on Main Street. When the fire department first organized in 1904, it consisted of three departments—the engine company, the hook and ladder company, and the hose company—each of which had its own responsibilities at a fire. The first officially logged fire occurred on December 8, 1904, at the cooper shop and house of George Murphy. In January 1906, a fire bell was installed in the steeple of the First Presbyterian Church. By February 1910, a large steam siren was installed at the Locke Insulator Company site. That year, Charles Longyear put in a bid to build the first fire building. His bid of $2,590 was accepted by the Victor Village Board. The fire department maintained this site until 1968, when the new fire hall on Maple Avenue was dedicated.

Victor Preserving Company opened in 1908 west of the Lehigh Valley Railroad tracks on School Street. Edward J. Tobin was its manager. During its first year of operation, the canning factory produced 250,000 cans. Victor Preserving became an important industry to local farmers and fruit growers. Victor Valley, Bridesmaid, and Stadium were labels of some of the fancier fruits. Pears, cherries, apples, peaches, strawberries, blackberries, and raspberries were some of the fruits that were sealed without solder or acid and shipped all over the country.

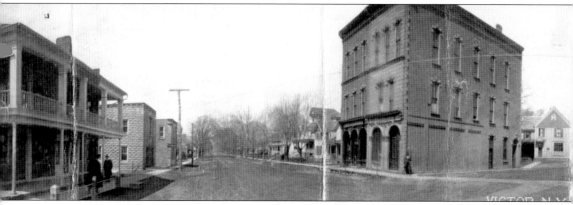

This unique panoramic view of Main Street in Victor about 1910 shows, from left to right, the Victor Hotel, the fire house, and the Moore Laundry Building. Across the street is the three-story bank building. In the middle is Dr. Mead's office on Moore Avenue. To the right are the Gallup

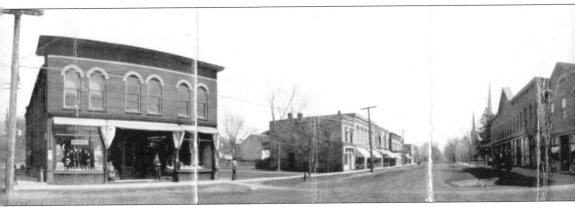

General Store, Pimm's Barber Shop, the Goodnow Block, Bristol's Meat Market, Heath Drug Store, and the Jacobs Harness Shop. Across the street are the Walling Block and A. Simonds and Sons Cobblestone General Store.

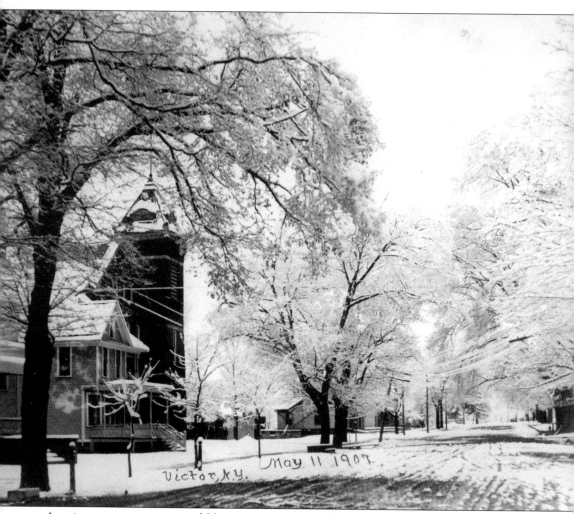

Victor, N.Y. May 11 1907

A unique snowstorm carpeted Victor on May 11, 1907. About seven inches of snow fell. The *Victor Herald* reported, "Never was Victor more beautifully garbed than on Saturday morning when a mantle of soft, pure-white snow covered the ground and every tree and outdoor object was draped with the clinging crystals."

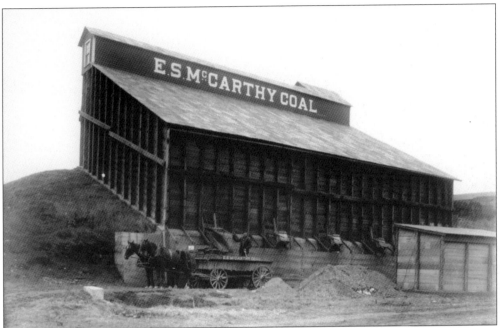

E. S. McCarthy Coal Company was built in 1909 on Maple Avenue at the foot of Boughton Hill Road near the tracks of the New York Central Railroad. The coal elevator was built to more effectively transfer coal from the railroad cars to the shed. The capacity to unload the coal was between 50 and 60 tons an hour.

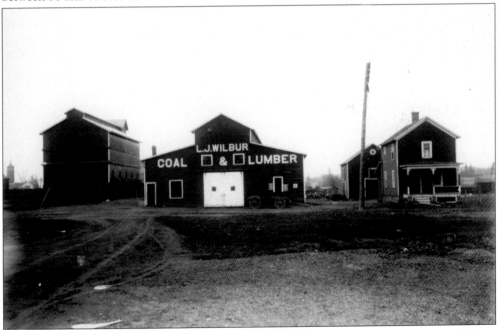

L. J. Wilbur Coal and Lumber Company was located on Maple Avenue at the site of Victor Insulators. A Sanborn Fire Insurance map of 1904 shows the Locke Insulator Manufacturing Company sharing space with L. J. Wilbur Coal and Lumber Yard. By 1909, the L. J. Wilbur Company had moved to School Street.

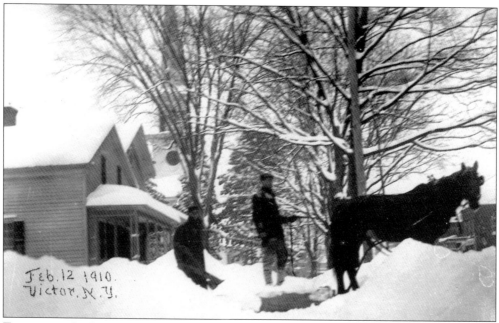

Two men and a horse plow the snow on East Main Street on February 12, 1910. Notice the Presbyterian church above the man on the left.

Pictured is Andrews Street in 1910, with several houses and St. John's Lutheran Church at the end of the street. Andrews Street, called Rowley on the 1909 village map, is a short road off Church Street. At one time, Dr. Andrew Rowley owned much of the land on either side of the present Andrews Street.

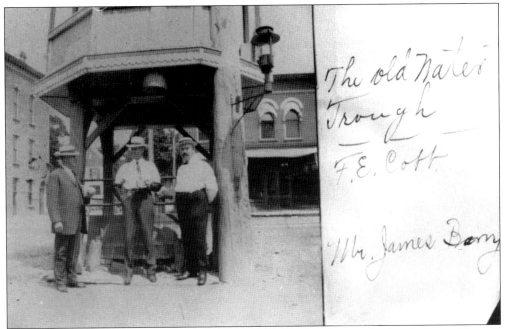

The old water trough is seen here with F. E. Cobb, James Barry, and Alex LaBarge. The old bandstand—located at the intersection of Maple Avenue, Moore Avenue, and Main Street—was removed in 1912 as more automobiles traveled through the village of Victor. A traffic light was installed at this site in June 1927.

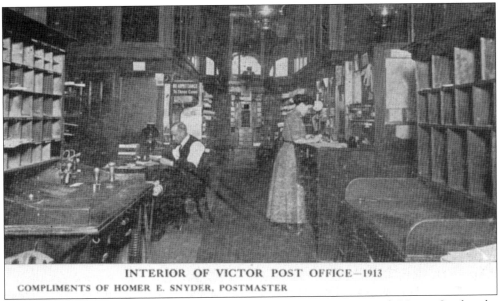

INTERIOR OF VICTOR POST OFFICE—1913
COMPLIMENTS OF HOMER E. SNYDER, POSTMASTER

This photograph shows the interior of the Victor Post Office in 1913 with Homer Snyder, the postmaster. When L. G. Loomis Sr. became postmaster in 1895, the post office location was moved to the bank building and remained there for 25 years.

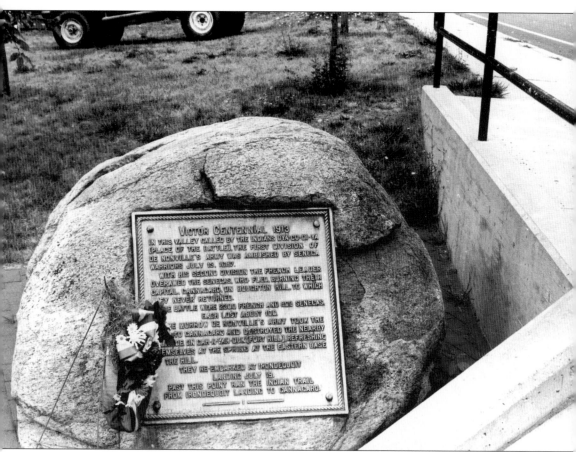

The Boulder Monument was dedicated in 1913, the centennial of the town of Victor. The monument was placed at the corner of High and West Main Streets to commemorate the battleground of the famous struggle of the French invaders under the Marquis Denonville for control of the beaver trade. The French attacked the Seneca capital on Boughton Hill in July 1687 and defeated the greatly outnumbered Senecas. Denonville and his forces went on to destroy all of the Seneca villages as well.

Three

THE COUNTRYSIDE

The town of Victor was first settled by the Boughton family from Stockbridge, Massachusetts. The original settlement was at the crossroads of Boughton Hill Road and the Victor-Holcomb Road—Boughton Hill. At first called Boughtontown, it was a stop on the east-west thoroughfare between Albany and Buffalo. Incorporated as a town in 1812, Victor was named after Claudius Victor Boughton, a hero of the War of 1812.

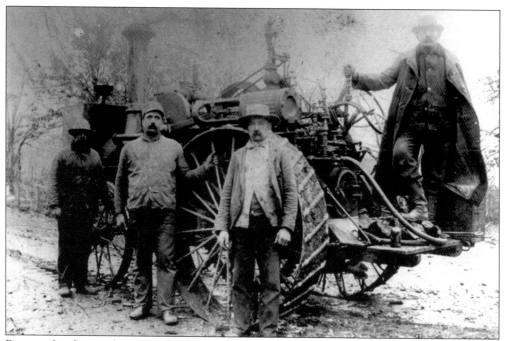

Bement family members and farmhands pose with a steam-driven threshing machine. This machine, which separated the grain from the straw, was the first one in Ontario County. The Bements farmed on Boughton Hill for 53 years.

"Victor's River" is the mighty Mud Creek, shown here from Osborne's lot on Maple Avenue. (Published by the Snyder Store.)

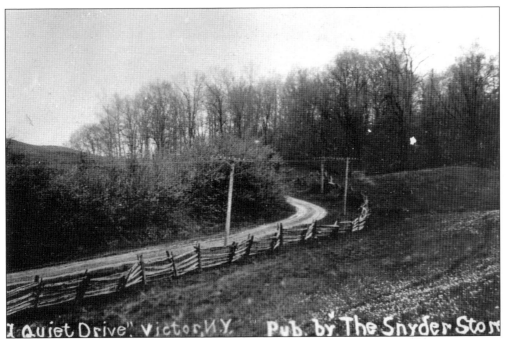

"A Quiet Drive in Victor" shows School Street and southward beyond the New York Central Railroad toward Hog Hollow. Hog Hollow was so named because of the Powell Cider Mill, whose refuse was used to feed hogs.

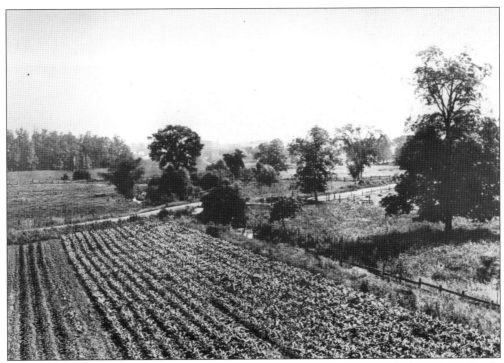

This photograph, looking north from the Powell Cider Mill, or Applejack Mill, shows Dryer Road.

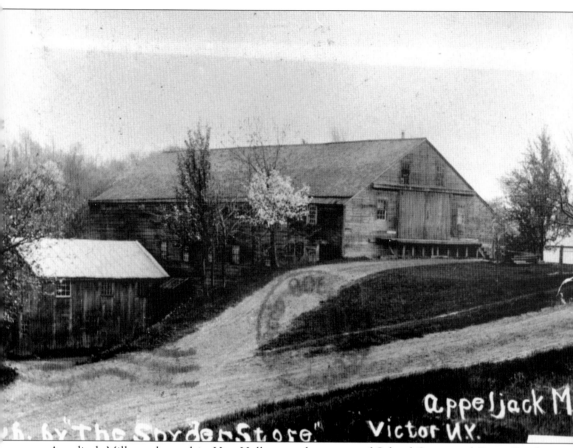

Appeljack Mill was located in Hog Hollow on the corner of School Street and Dryer Road. The cider-and-vinegar mill was built in 1869 by C. L. Powell. A newspaper had the following comment on the mill: "The Powell Cider Mill was a good asset to the town as there was always a market for the cider apples and in addition, you could get a touch of apple jack such as has never been produced since Powell went out of business."

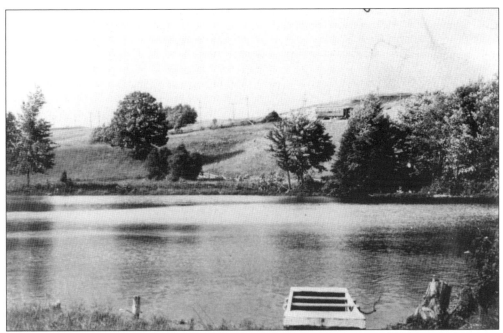

Crossman's Pond, west of Victor, is pictured in 1910. The pond was formed by glaciers that once covered Victor. The glacial formation, called a kettle, is one of the many unique structures found around the Fishers area. In the 1870s, Hiram Crossman wintered in South America and brought home a giant sea turtle and some lizards from the Galapagos Islands to live in his pond.

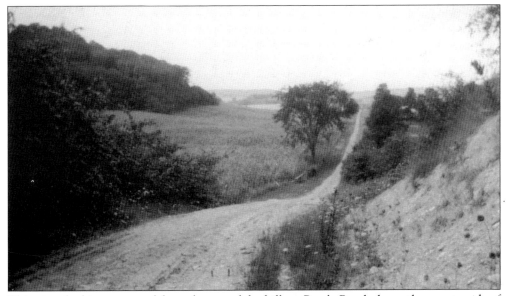

This view, looking westward from the top of the hill on Bortle Road, shows the countryside of Victor in the early 1900s.

Mud Creek, east of Victor, was important to the early development of industry in East Victor. In the early 1800s, sawmills, gristmills, and carding mills were prevalent. Mud Creek water was used to power the mills. As the railroads came to the center of the village of Victor rather than to East Victor, industry diminished here. Ezekiel Scudder founded East Victor in 1810, thus the name Scudderville. East Victor was also called Snuffville, because of the supposed large numbers of snuff users (including women), and Friedon.

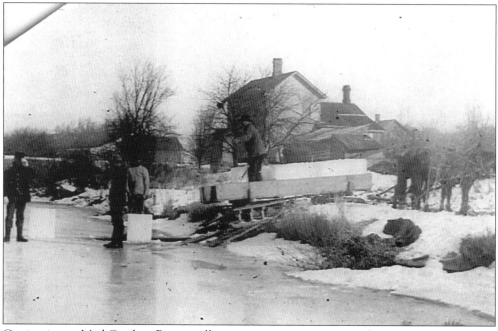

Cutting ice on Mud Creek in Brownsville was once a very common sight in winter.

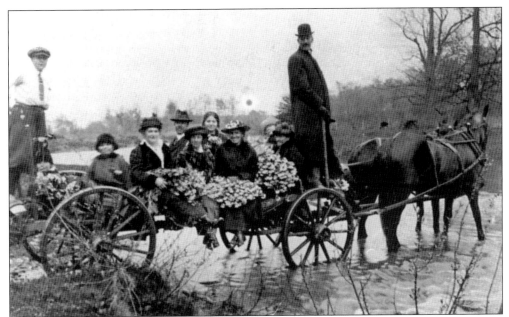

Bluebell Sunday at the Marquis (Bowerman) Farm in Brownsville is seen here in 1913. Bluebell Sunday started in the early 1900s by Bert and Carrie Marquis of Cline Road. The family recognized that the sight across Mud Creek filled with bluebells that grew in such profusion should be shared. Early on, friends or relatives would take the trolley from Rochester and stay overnight with the Marquis family. Hooking the buggy up to the horses, family and friends took the ride through Mud Creek to the other side. The flowers usually bloom in late April or early May. The tradition was carried on with Ruth and Brice Bowerman Sr. Today the custom still continues with the Armstrongs, who live in the family homestead.

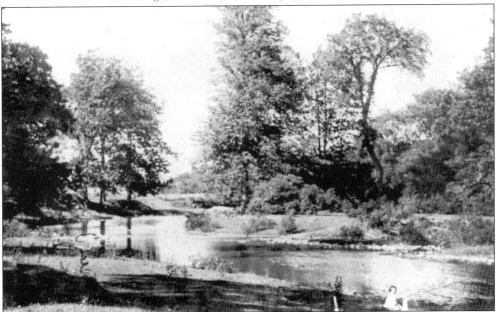

Pictured in 1908, Ruth Marquis Bowerman shows the path on Mud Creek where the wagon crosses on Bluebell Sunday.

The Plastermill, located in East Victor, had a deposit of gypsum near the surface that, beginning in the 1830s, was mined as fertilizer. Later on, a building was put up for a furnace that would extract the lime from the gypsum to be used for mixing with cement to make concrete. By 1927, a mine was dug 110 feet under the ground to bring out a higher grade of gypsum. It was the first and only shaft gypsum mine in the United States. About 400 tons of gypsum were removed daily. The mine was closed prior to World War II.

High Street, about 1904, was an unpaved dirt road leading from the village to the country homes Hillcrest of the Ladds and Prosperity Place of the Boughtons, the Catholic cemetery, Valentown Hall, the District No. 7 Cobblestone School, and the Bonesteele Homestead.

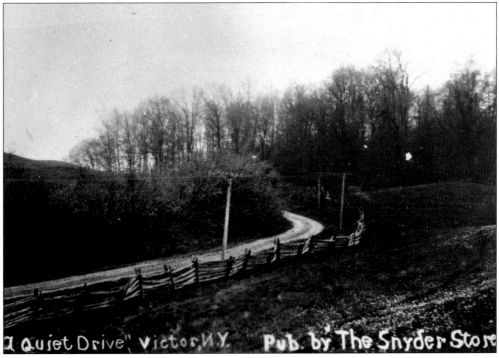

A quiet drive in the countryside of Victor is apparent in this photograph. (Published by the Snyder Store.)

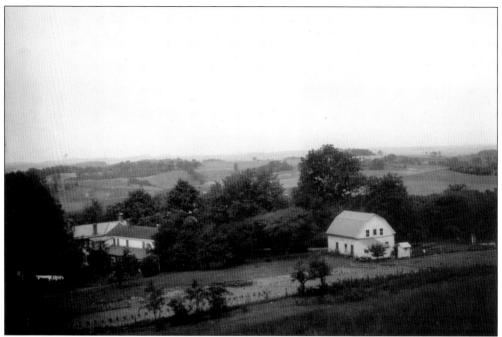

This view from behind and above the Bonesteele Cobblestone House on High Street Extension in the early 20th century shows the Bonesteele House on the lower right, and in the distance is the Bonesteele farmland where Eastview Mall now stands.

This photograph shows a winter scene of the Victor-Pittsford Road (future Route 96) as a dirt road at the fork with Lower Fishers Road. The road was widened to two lanes and paved with concrete by the state in 1927. At that time it was designated as Route 15. The road is looking south and is now just south of the High Street intersection with Route 96 at Eastview Mall.

Four

PEOPLE AND HOMESTEADS

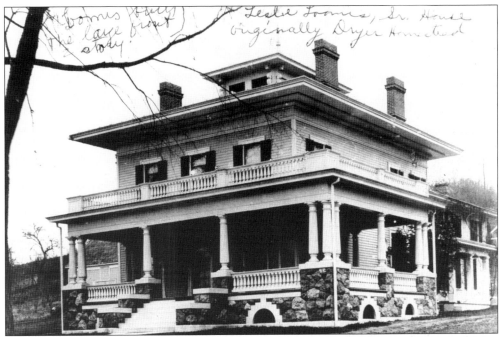

The Leslie Loomis Sr. House, on West Main Street, was originally the Dryer Homestead. This Federal Italianate–style house was built in 1838 by William C. Dryer. Leslie Loomis Sr. was a prosperous farmer until 1877, when he became a clerk for E. S. Norton (a produce dealer) until 1882. After that time, Loomis began his own business of selling produce under the name of Loomis and Woodworth and then L. G. Loomis and Son. In 1893, his company did a business of $950,000. Loomis was the town of Victor supervisor from 1846 to 1848 and also in 1868. Loomis added the porch and Italianate architectural features to his home around 1900. He also had the carriage house built at that time. This house had the first running water in Victor.

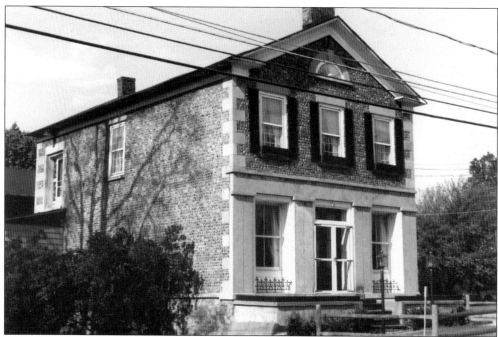

The Felt Cobblestone is in East Victor on Route 96. This Greek Revival cobblestone was built about 1836. For over 70 years, it was operated as a general store by the Goldfarb family. It has a facade of cut stone piers and a stone entablature on the first floor. It is in the National and State Registers of Historic Places.

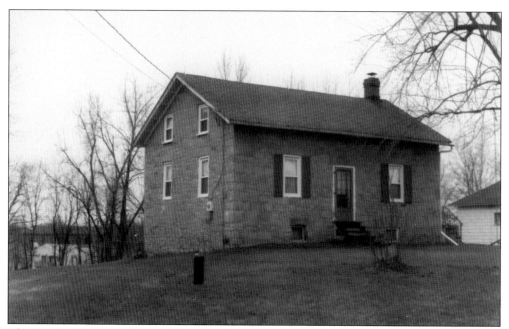

The Hawley House on Break of Day Road in East Victor is the only original stone house built in Victor. It was built around 1822 by Thomas Hawley with the help of his son, Erie. Thomas Hawley was a farmer and sawmill operator.

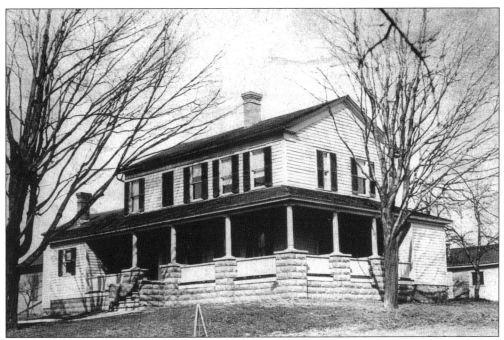

The Boughton Homestead on High Street was built in 1827 by Caleb and Irene Boughton to replace a log cabin that had burned. Behind the house is a smokehouse and a blacksmith shop.

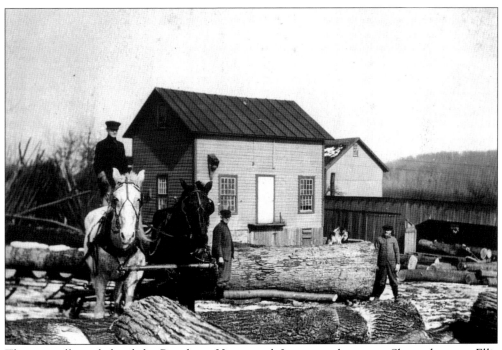

This sawmill was behind the Boughton Homestead. It was run by steam. Shown here are Ellis Boughton (behind the log—he had the mumps and did not want to be photographed), Herman Boughton, and Myron Boughton.

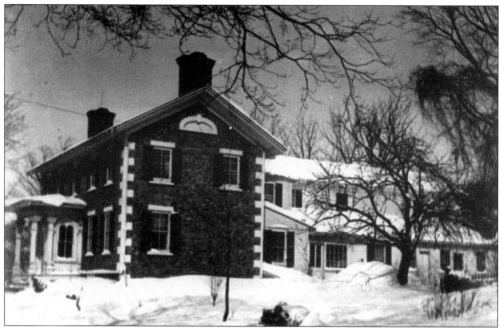

The Bonesteele Cobblestone House was built in 1835 on High Street Extension by Philip P. Bonesteele. It is in the Federal style, with a later addition of an Italianate front porch. Bonesteele wrote in a letter to the *Cultivator* magazine in March 1842 that he furnished all of the materials for the house from the ground, paid his mason $3.75 per 100 feet, and made the house so strong and tight that a pin could not be stuck into any crack and so weatherproof that it never needed to be painted. Bonesteele was the town of Victor supervisor in 1849 and a prosperous farmer, as well as a tavern keeper who operated Poplar Inn, on the opposite side of Turk Hill Road, west of the homestead. The temperance movement led Philip Bonesteele to close his tavern.

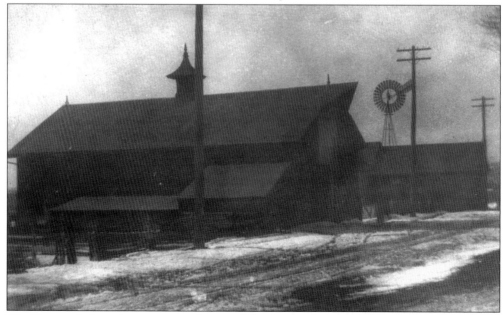

The Bonesteele barns were once on the site of the present Eastview Mall.

Frank Bonesteele, grandson of Philip Bonesteele and husband of Sarah Hall Bonesteele, is shown here with his dog Tad.

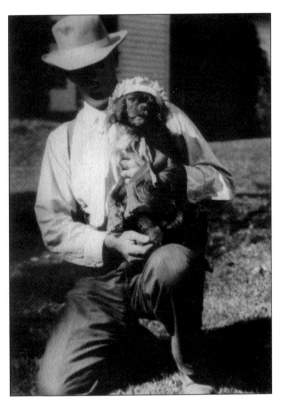

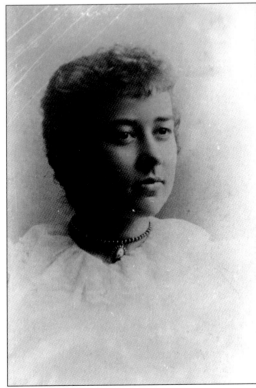

Sarah Hall Bonesteele was one of the first female graduates of the Massachusetts Institute of Technology. She moved to Victor in 1898 after marrying Frank Bonesteele. She studied art at the old Mechanics Institute in Rochester and became an expert weaver. After the death of her husband, Sarah Bonesteele decided to travel across the United States, at age 50, in a 1921 Buick 6. She was accompanied by her friend, Hermoine Leu. With a hand-cranked car, primitive gas stations, many unpaved roads, no adequate road maps, and few hotels, the women courageously traveled over 5,000 miles.

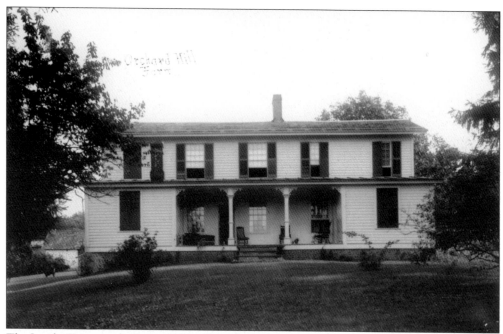

The Lauder Farm was built in 1832 and bought by John A. Lauder in 1855 from a Mr. Snedeker. At one time, the farm had a dried apple business and was called Apple Tree Farm. On this photograph, it is called Orchard Hill Farm. It was a Century Farm nominee because it was in one family for at least 100 years. The Lauder family still resides here.

John W. Lauder was born on the Lauder Homestead on Gillis Road. A prosperous farmer, he married Cora Marquis, and they had 10 children. Lauder served as the town assessor for over 35 years. In 1909, he was elected town supervisor.

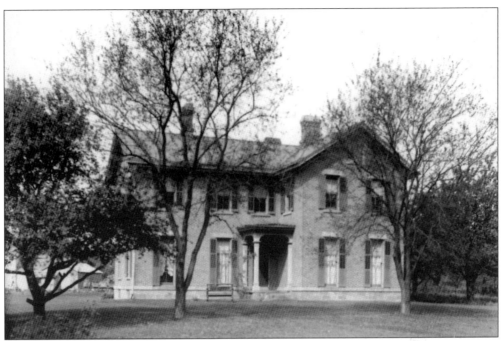

This brick farmhouse on Benson Road was built on land owned by Simeon Parks, a prosperous Fishers farmer. The land was deeded by Simeon Parks to Philo Parks, and then it was bought by Ichabod Benson in 1856.

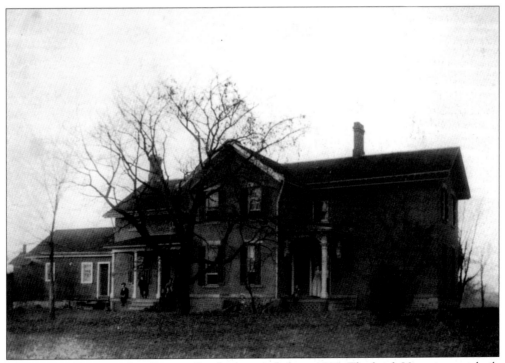

The Benson Homestead on Benson Road is pictured about 1900. The brick Victorian was built in 1867 by Alonzo Benson.

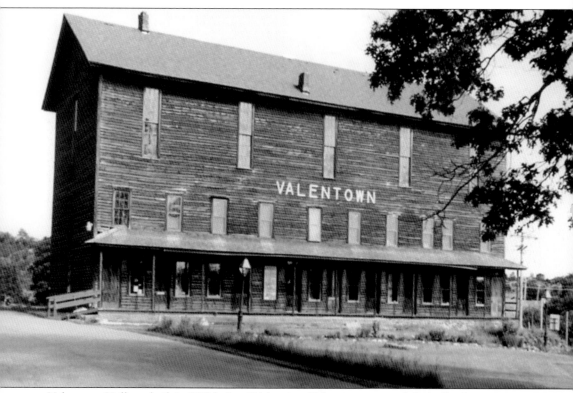

Valentown Hall was built in 1879 by Levi Valentine. Valentine expected the hall to be in proximity of the Pittsburgh, Shawmut, and Northern, a railroad that was to go through the northwestern part of the town of Victor. Under the direction of master carpenter Giles Wood, the three-story structure was built. It opened on George Washington's birthday in 1881 with a grand concert and ball. The building was a forerunner of an indoor mall, with first-floor stores—a meat market, a cobbler's shop, a harness shop, and a dining room. The second floor held a business school, a school of acting and music, and meeting rooms for the Victor Grange and the Independent Order of Good Templars. The third floor was used as a ballroom, with its 18-foot-high ceiling. In the basement, stables could hold as many as 80 horses. The railroad was not built near the hall. Valentown Hall was later purchased by J. Sheldon Fisher to be used as a museum. It was called Valentown because Valentine used part of his name and part of his grandfather's name, Ichabod Town.

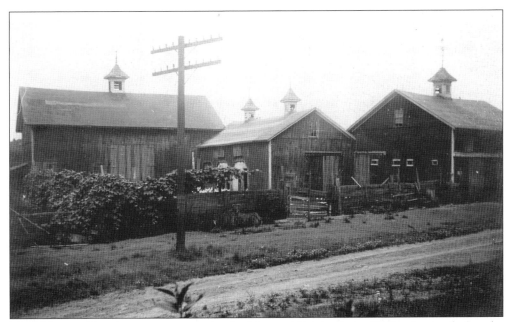

The Valentine Farm barns were painted red, white, and blue by Samuel Valentine just before the Civil War. His barns became known as the Union Barns. Every Fourth of July, an all-day picnic was held, with a patriotic program including fireworks, a band concert, and fiery speeches that inspired many young men to join the army.

The Ichabod Town home, a Greek Revival structure, was built about 1830 by Noah Baker II. Ichabod Town was a cooper who came to Victor from Cazenovia, New York, in 1809. In 1892, the home was owned by George Pickering. His wife, Jane A. Baker Pickering, the first female doctor in Victor, set up her office in the Ichabod Town house (then called the Valentine Farm).

Edward "Stonewall" McCrahon enlisted in the Civil War with the 7th Louisiana Infantry and was in the battles of Bull Run, Antietam, and Gettysburg. McCrahon was nicknamed "Stonewall" for having served under Stonewall Jackson and being his orderly. He was captured at a skirmish near Rappahannock Station, Virginia, on November 7, 1863, but was released after three months imprisonment. He then decided to take the oath of allegiance to the United States. His boyhood home is on Log Cabin Road in Fishers.

Alexander McCrahon, brother of Edward, was 16 when he enlisted to fight for the Union in the Civil War. He became a private in the 108th New York Volunteer Infantry in August 1862. He later transferred to the 4th Artillery Regulars. At Gettysburg, on July 3, 1863, he was seriously wounded in the leg. He fought against his brother Edward McCrahon at Antietam and Gettysburg, although neither brother realized it until returning home after the war. His boyhood home is on Log Cabin Road in Fishers.

James and Irene Nelson Moore, lifelong residents of Victor, are shown in this photograph. Moore was among the first men to enlist as a soldier of the Civil War to fight for the preservation of the Union. He fought at Antietam and Chancellorsville. He was taken captive and held at Libby Prison, where after eight days, he was released in exchange for a rebel prisoner. Upon returning from the war, Moore resumed the occupation of carpenter and builder.

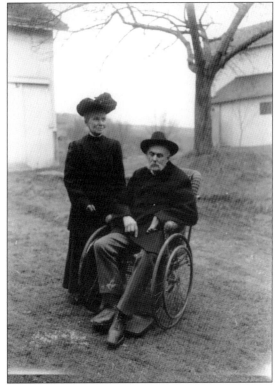

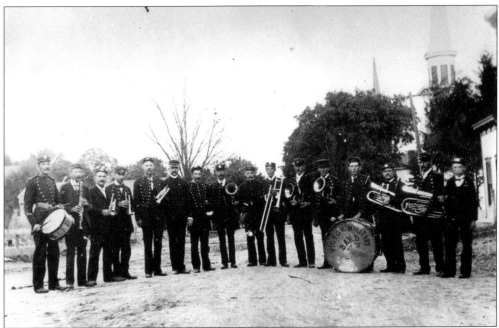

Members of the Victor Military Band are, from left to right, Charles VanVechton; Charles Webster; Hart Gillis; Mack Mosher; Charles Schrader; William Brace, director; Arthur Webster; George Underhill; Maney Brace; Fred Bortle; Grant Cline; Charles Cline; Thomas Hunt; Fred Marks; Irving Cline; and Charles VanVechton Jr.

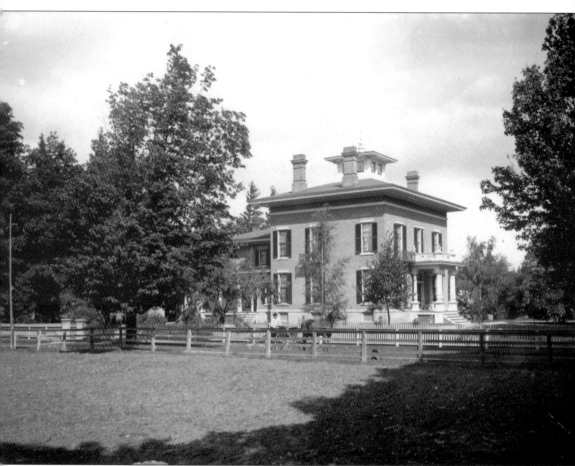

The D. Henry Osborne Home was built around 1855 by architects Merwin Austin and A. J. Warner. The two-story brick Italianate had approximately 18 rooms and original features such as a four-seat attached brick privy. The land for the house was purchased by William Bushnell, Victor's first permanent merchant. Bushnell, after which Bushnell's Basin is named, made his wealth trading in the commercial area along the Erie Canal. In 1847, his daughter, Lavina Amelia, married David Henry Osborne. Shortly afterward, they inherited the large tract of land on Maple Avenue. The Osbornes raised three children in this home, all of whom were given the same middle name—William Bushnell, Cora Bushnell, and Carrie Bushnell Osborne. Only two families have owned this home.

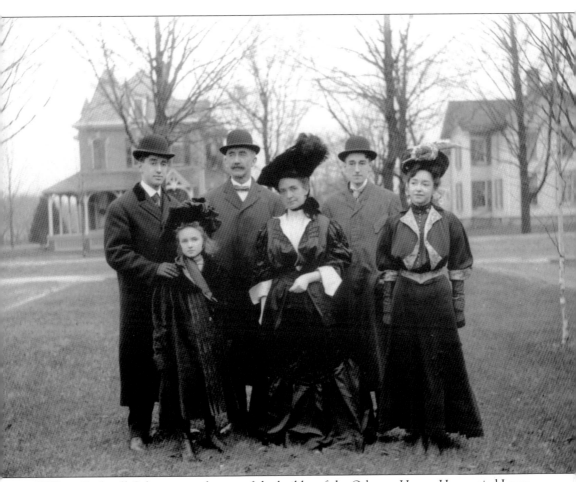

William Bushnell Osborne was the son of the builder of the Osborne House. He married Laura MacDonald in 1881 and had five children, David Henry, William Bushnell, Elizabeth MacDonald, Cora Lavinia, and Ruth MacDonald Osborne. The family is pictured here. Osborne served as supervisor of Victor from 1890 to 1891 and as sheriff of Ontario County from 1895 to 1898. He then returned to Victor and became active in farming.

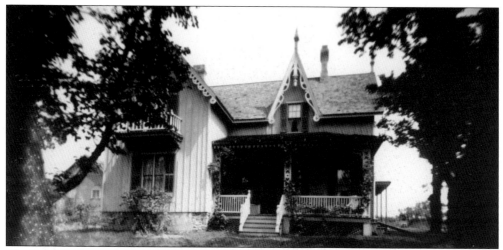

The Lobdell House on Webster Heights (behind Moore Avenue) sits on the site of the former Proprietor's Meeting House. This house was built about 1855 by Sylvester Howe. Many of the timbers and some of the windows from the old meetinghouse went into the building of this residence. It was first used as a parsonage by the Victor Universalists and later became the Lobdell home. The Lobdells are descendants of Jacob Lobdell, who at age 18 stayed by himself in Victor during the winter of 1789 to tend the cattle when the Boughtons went back to Massachusetts to get their families.

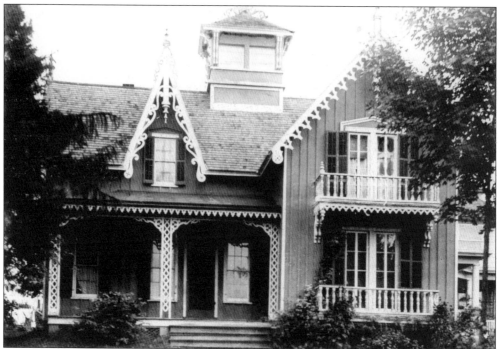

The Webster Home on Webster Heights was built in 1867 by David E. Sizer. The house occupies the eastern half of the original Proprietor's Meeting House site. It was built using the same plan as the Howe house on the western half of the meetinghouse site but with a reverse plan. Milo Webster bought the house about 1911, and he and his wife raised 12 children there. The house was enlarged to 26 rooms to accommodate the large family.

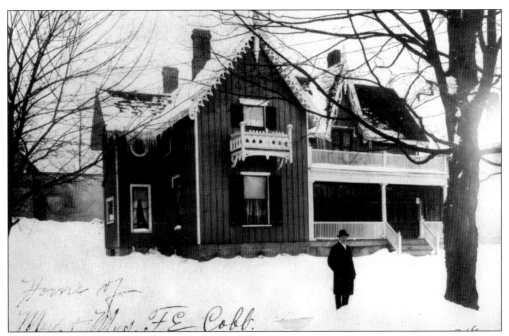

The F. E. Cobb Home on West Main Street was built about 1877 in the Gothic Revival style with gingerbread ornamentation. It was the home of Frank and Frances Goodnow Cobb until her death in 1922. Cobb later married Clara Jones in 1938. For 50 years, Cobb was in the drug and stationery business in Victor.

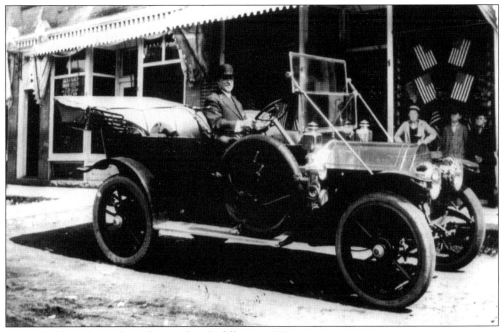

Frank Cobb is shown here driving his Cadillac in 1913.

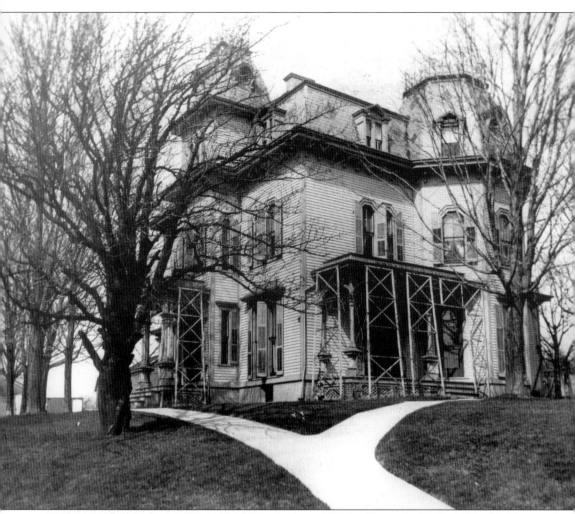

Hillcrest was a three-story Victorian house built in 1873 by Hiram Ladd. In 1938, the Victor Central School District chose the Ladd Farm on High Street for the site of the new centralized school district. A 175-acre parcel of land was bought for $5,000 from Fannie Ladd Locke. The Ladd Farm consisted of the former Perkins and Dryer farms, which were purchased and combined by Hiram Ladd. (Published by the Snyder Store.)

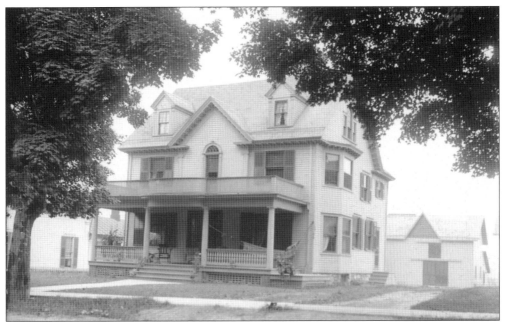

The house at 26 Maple Avenue was the residence of the Lewis Simonds family. Son of Albert Simonds, of the Simonds and Sons Cobblestone General Store, Lewis Simonds worked in the family business for 42 years. He married Bertha French in 1879, and they had five children, Lucile, Olive, Doris, Warren, and Russell French.

Bertha French Simonds was the wife of Lewis Simonds.

Dr. Alfred M. Mead was a horse-and-buggy (or sleigh, depending on the weather) doctor in Victor from 1880 to 1939. He started his practice in the three-story bank building and then moved to the little house at the intersection of Moore Avenue and Webster Avenue. Practicing for nearly 60 years in Victor, Mead for a long time charged 50¢ for an office call and $1 for a house call. During a tribute at his funeral, it was said that "His life was one of a twenty-four hour service—going morning, noon, and at midnight—all this rising from that lofty desire to help others." Mead served his community as a village trustee, a member of the board of education for 25 years, and a trustee for the First Methodist Church.

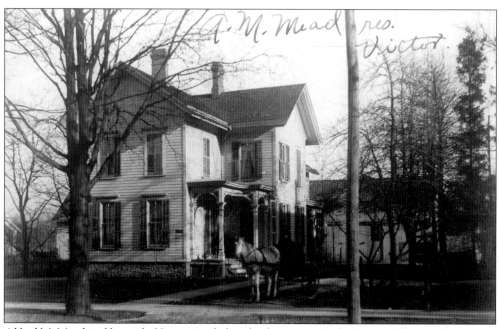

Alfred M. Mead and his wife, Hattie, resided in this home on Maple Avenue. The Meads married on April 6, 1881, and had three children, Edgar R., Dora E., and M. Evelyn Mead.

The residence of Zibe Curtice is shown here on Maple Avenue about 1900. Curtice was an undertaker whose building burned in the great Main Street fire of 1898. He served as the village president from 1894 to 1895.

Alden Covill and his wife built this home on Maple Avenue in 1872. They sold the home to Chauncey Felt and his wife. About 1910, Clara G. Felt and her sister, Delia A. Felt, resided in the home. Always greatly interested in Americanization, Clara Felt bequeathed money upon her death in 1923 to the high schools of Victor and Pittsford, providing for annual prizes for the best essays written by the students on the subject "What Does the Constitution of the United States Mean to Us as Citizens?"

Willis D. Newton married Jennie Aldrich and lived in this home, which he built in 1881 on Maple Avenue. He was supervisor of the town of Victor from 1892 to 1893 and from 1898 to 1900, and president of the village from 1886 to 1891. A local cigar manufacturer, Newton had business competition from M. K. "Curly" Sage.

This American foursquare house on Maple Avenue was built for Dr. and Mrs. Everett Sharp in 1910. The garage was built from the wood of the original St. Patrick's Catholic Church. Sharp practiced dentistry in Victor for nearly 59 years. His office was on the second floor of the old three-story bank building. He was the second person in Victor to own an automobile.

William Bushnell, Victor's first merchant, is said to have built this house on Maple Avenue in 1824. It was the longtime home of Alden Covill, a prominent farmer who owned many acres on Maple Avenue. It stayed in the Covill family until 1925. Mrs. Covill traveled to New York City in the winter and summered in Victor. She divided her house so that one part became a rental and the other section her summer home. It is suspected to be the oldest unchanged home in the village.

In 1840, John D. Gillis built the Gillis Homestead in the New England style of architecture on Gillis Road. Gillis was a blacksmith for a number of years and later a farmer. The homestead, which stands in the northern part of town—an area of rich and productive farmland, has always been occupied by a member of the Gillis family.

Dr. Charles Andrew Rowley was a physician who practiced in Victor from 1888 until his death in 1927. He specialized in the diseases of women and children, as well as surgery. Rowley served as health officer and was on the board of education. He married Stella Power in 1897, and they had one child, Gladys Jeanette Rowley.

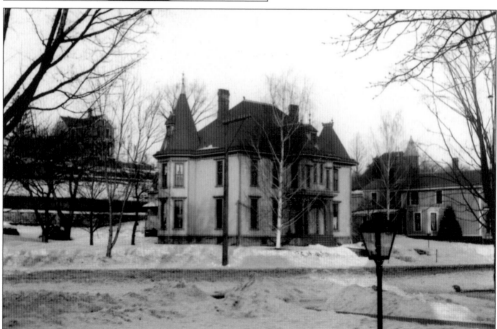

This Victorian-style home on East Main Street was first occupied by prominent resident Orin Stebbins Bacon. Afterward, because medicine was practiced here for over 100 years by about 25 physicians, it became known as "the Doctor's House." Charles Andrew Rowley was the first physician to start the tradition.

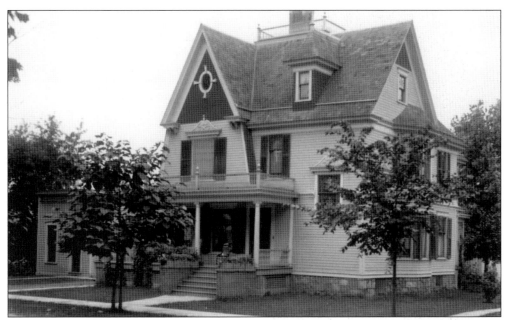

Dr. Cassius O. Jackson came to Victor in 1880 to practice medicine in a little brick building east of the old Walling Block, which is no longer on Main Street. Jackson then moved to this home on West Main Street. In 1901, he was succeeded by Dr. Clapper, who set bones, performed surgery, and pulled teeth, as he had some training as a dentist. Clapper also served as the town supervisor from 1905 to 1908.

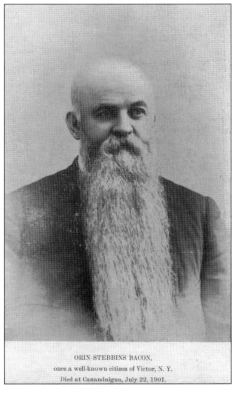

ORIN STEBBINS BACON,
once a well-known citizen of Victor, N. Y.
Died at Canandaigua, July 22, 1901.

Orin Stebbins Bacon was president (mayor) of the village of Victor from 1883 to 1886. He ran a meat market in Victor from 1859 to 1884 and, earlier, was a dealer in cattle, beef, horses, and real estate. He also served as a collector of taxes for the town of Victor, undersheriff and sheriff, and financial manager of a private bank in Canandaigua. He married Harriet Hubbell Simonds in 1856, and they had five children.

Marvin A. Wilbur was educated at Colgate University and originally was a teacher, but gave it up because of ill health. He became a farmer and then had a mill. In the mid-1870s, Wilbur became a dealer in horses. By the early 1880s, he had become a partner in the banking firm of Parmele and Hamlin. He was the town of Victor supervisor from 1883 to 1886 and from 1896 to 1897. Wilbur married Ida M. Dewey, and they had two children, Lee and Laura.

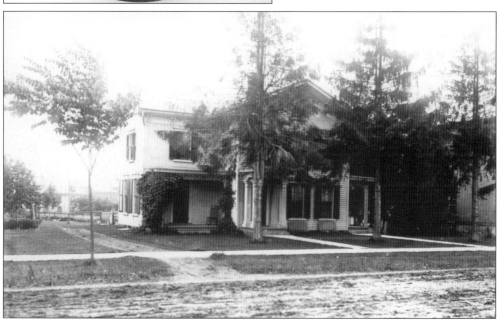

The Marvin A. Wilbur home on East Main Street is shown here about 1900. On a map from 1879, the M. A. Wilbur home was called Fairlawn. This home was built in 1840 by Col. Melancton Lewis. Lewis came to Victor in 1838 at the age of 43 to be the first teacher at the village school. In 1844, he set up a foundry business with Albert Simonds and stayed in that business until his death in 1857. The house was torn down in the late 1950s or early 1960s.

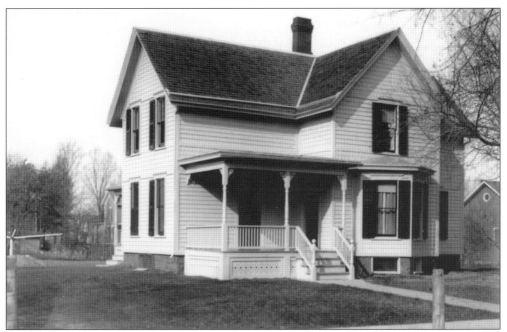

The Martin Van Buren Snyder and Maria Bonesteele Snyder home is on Covill Street. Having lived on the Snyder farm at Valentine Hall for 43 years, the Snyders bought this home in 1909. Snyder was a Union soldier in Company K, 154th New York Volunteer Light Infantry. The Snyders had nine children.

This home on East Main Street was once the home of Charles Longyear, who supervised the construction of the old fire hall on East Main Street and the Fishers School on Wangum Road in 1910. In the 1920s, Longyear moved to Cleveland and then to Arizona. He returned to Victor in 1946 at the age of 82. At that time, he purchased 24 acres of land on Church Street from the Avery Brown estate. Longyear then proceeded to build Victor's first subdivision after World War II. He had 17 lots sold, some with houses on them, when he died at the age of 87 in 1952.

Willis G. Hill lived in the village in this home on West Main Street for a short time while he worked at Locke Insulator. He spent most of his life on the farm where he was born on Willis Hill Road and where he passed away. His wife was Margaret Cline Hill, and they had one daughter, Ruth Hill Simonds, and one son, Roscoe C. Hill.

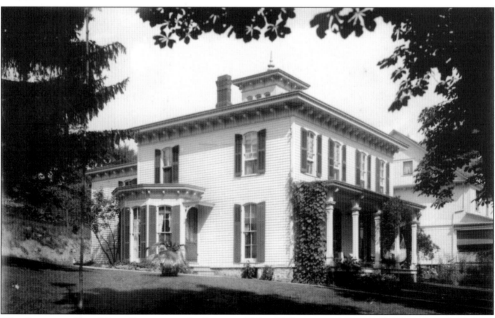

This home on East Main Street was the home of John F. Frazer and then of Milton Smith. Frazer, a tinner by trade, opened Victor's first hardware store. He was in business for more than 50 years. He was also the village president for two years and a member of the board of education for six years. Originally a farmer, Smith was later employed as a stockkeeper at the Locke Insulator plant and as a clerk in the Gallup Store and in the F. E. Cobb Drug Store.

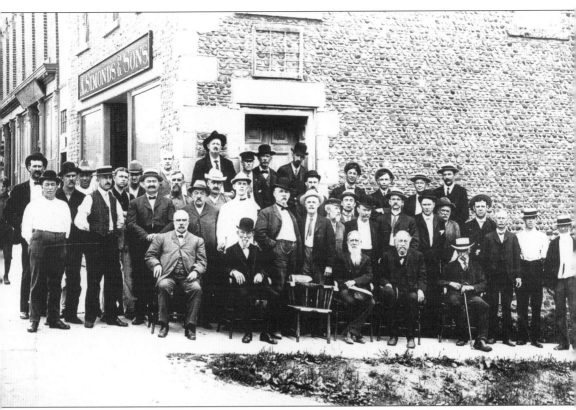

Victor businessmen pose for this photograph about 1880 on the side of the old Simonds and Sons Cobblestone Store on the corner of East Main Street and Maple Avenue. Shown from left to right are as follows: (sitting) George Brusie, blacksmith; Josiah Snyder, farmer; Albert Simonds, merchant; (standing) Jehial Macumber, wagon maker; James Walling, tailor; Lew Frost, farmer; Samuel Osborne, wholesaler; George West, cutter; Stephen Jacobs, harness maker; Seymour Sale, farmer; William Magison, tailor; William I. Turner, boot and shoemaker; William Dryer, Victor Hotel proprietor; Levi Lobdell, farmer; William Gallup, merchant; Asa Loveland, farmer; Elisha Peck, farmer; and David Heath, wagon maker.

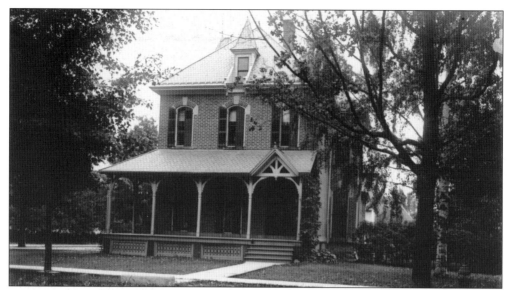

The house at 2 East Street was the home of Hamilton French and later W. A. Higinbotham. French built this brick structure in the 1870s and later planted maple seedlings from his farm along the street—hence the name Maple Avenue. It used to be called Railroad Avenue. W. A. Higinbotham came to Victor in 1883 and went into partnership with Hiram T. Parmele and Henry W. Hamlin and established a private bank in Victor. Eventually the institution became the State Bank of Victor in 1921, and in 1957, the bank merged with Canandaigua National and Trust Company.

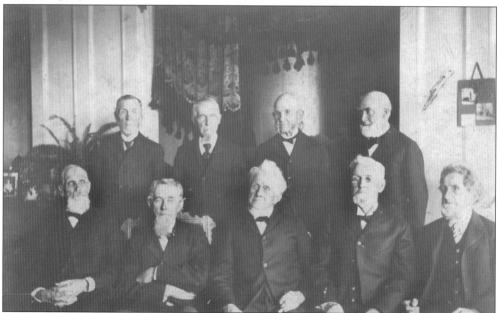

Alexander H. French's 87th birthday party was held on February 4, 1903. His oldest friends attending were, from left to right, as follows: (first row) I. E. Humphrey of Victor, age 84; Richard Cline, of Perinton, age 72; Alexander H. French; John Olney of Rochester, age 78; and John Conover of Victor, age 85; (second row) Hiram Swezey of Batavia, age 78; Seymour Sale of Victor age 78; Jabez Wilder of Victor, age 82; and J. G. Mead of Victor, age 78.

Pvt. James Cooke was the only one of the 83 men serving from Victor to die from combat wounds in World War I. He lost his life on September 16, 1918, in France. The James Cooke American Legion Post No. 931 in Victor is named in his honor. Two other men died of disease: William A. Barton and William Finear.

Dr. Charles Ball came to Victor in 1836 to join his brother, Dr. William Ball, in his practice. Charles Ball, a quiet person with a kindly disposition, was very sympathetic and had a calming effect on his patients. He married Ann W. Page in 1845. He served Victor as a doctor for 44 years.

Stephen VanVoorhis came to Victor in 1853 with his parents from Otsego County. He farmed for many years for his parents, who lived in Fishers. Stephen was the Fishers postmaster from 1889 to 1892. After he retired from farming, he and his wife, Carrie Porter VanVoorhis, and their children, Margaret, Mabel, and Menzo, lived in this house on West Main Street. Stephen was on the town board of assessors for many years and also was the town supervisor in 1887.

Bolivar Ellis was a farmer, surveyor, and conveyancer in Victor. In 1882, he was elected county clerk of Ontario County. He served the town of Victor as a justice of the peace, a member of the town board for 24 years, and supervisor from 1880 to 1882. He was married in 1874 to Frances Lobdell, and they had one child, Isabel.

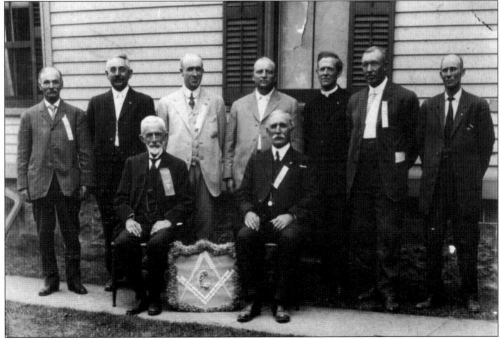

Masons at the 1913 town of Victor centennial are, from left to right, (seated) Bolivar Ellis and Eugene Barry; (standing) Henry Parmele, Charles Paddelford, Frank Cobb, unidentified, Rev. E. P. Wood, Edgar Case, and unidentified.

Charles Brown was the Victor town clerk for 46 years until his death in 1938 at the age of 86. It was said that Brown was the oldest man to hold the position of town clerk in all of New York State at that time. He also clerked in the drugstore of Frank E. Cobb for over 40 years prior to his retirement in 1932. Brown married Mary E. Camp in 1880 and had two children, Tuthill and Vera Brown.

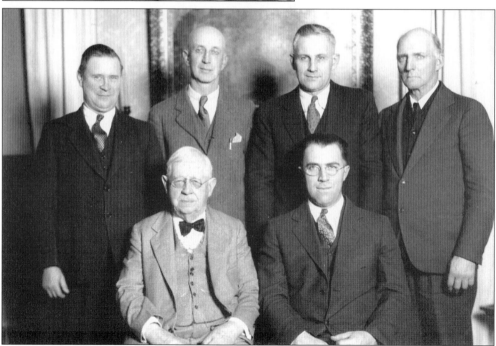

This formal picture of Victor Town Board members shows, from left to right (seated) Charles Brown and John Woolston; (standing) Fred Allen, "Si" Snyder, Archie Cuykendall, and Charles Phillips Sr.

Five

CHURCHES

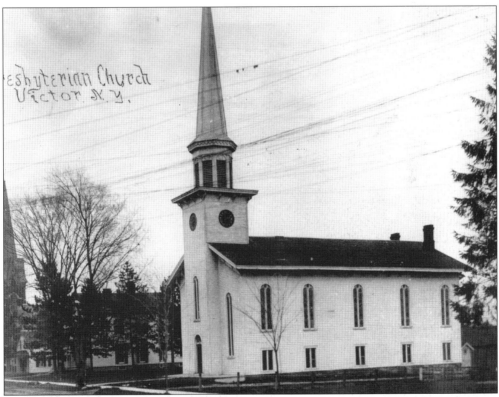

Victor's first church community was formed by the Presbyterians in 1798. The First Presbyterian Church, built in 1832, is the oldest church in Victor. The land on which the church is built was donated by Nathan Jenks. The original pulpit is still in the sanctuary. In 1860, a new spire was built and a bell was purchased for $500 and erected in the new spire along with the town clock. In 1870, Col. Melancton Lewis donated a $2,000 pipe organ, which was rebuilt about 100 years later.

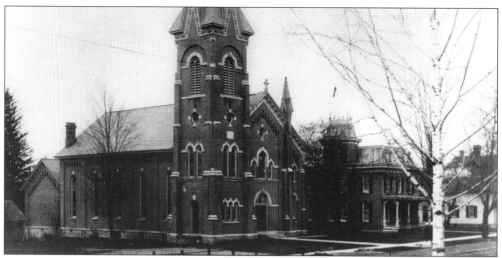

In 1819, the Methodists in Victor voted to incorporate and become part of the Methodist Church in the Bloomfield Circuit. A frame building was built in 1821 by Jeremiah Hawkins and Nathan Loughborough on land purchased for $40 from William Bushnell. In 1838, the male members of the Methodist Episcopal church and congregation met to incorporate the society according to law. The original church was later sold at auction in 1868, when the current Romanesque-style brick structure was built and completed in 1870. The building was completed at a total cost of $17,000 and was dedicated on June 15, 1871. The church structure originally had a steeple that rose more than 138 feet. After the spire was hit by lightning several times, the upper portion of it was removed in 1919 and refinished with a weather vane.

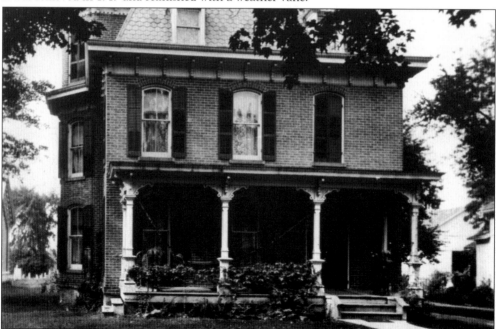

The architect of the Romanesque-style church and manse was John B. Thomas of Rochester, and the builder was Hiram Kingsbury. The manse was built on East Main Street in 1875 for $3,771.02. All rooms in the manse have 12-foot-high ceilings. A widow's walk and a mansard roof cap the parsonage.

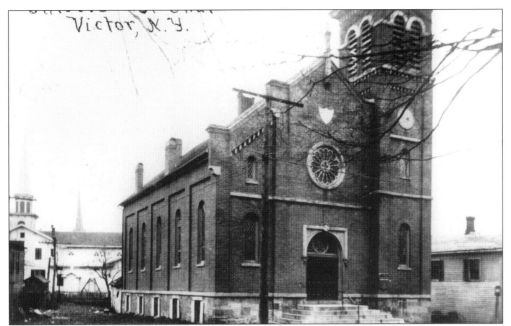

The Universalists formed into a church in Victor in 1845. They held their services in the Proprietor's Church on Webster Heights until their brick edifice on Maple Avenue was completed in 1856. St. Paul's Universalist Church invited the growing Catholic congregation to hold services in the basement of the church. The Universalists had a sharp decline in their membership, and thus in 1928, the church building was sold to the Milnor Lodge, Free and Accepted Masons. The pipe organ went to the Catholic church, and the communion table became the altar of the Methodist church.

Seniors in front of the Universalist church include George Simonds, Leslie G. Loomis Sr., Bolivar Ellis, and John Colmy.

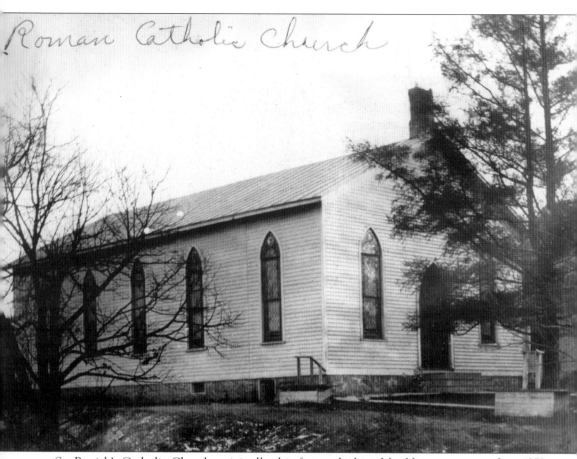

Roman Catholic Church

St. Patrick's Catholic Church, originally this frame clapboard building, was erected in 1859. The building site on Maple Avenue was purchased from the Ball family for $290. In 1882, the Reverend Angelo Lugero became the first resident pastor. In the early 1900s, parishioners were so numerous that it was the largest congregation in Victor. A new English Gothic–style brick church and rectory were built in 1924–1925.

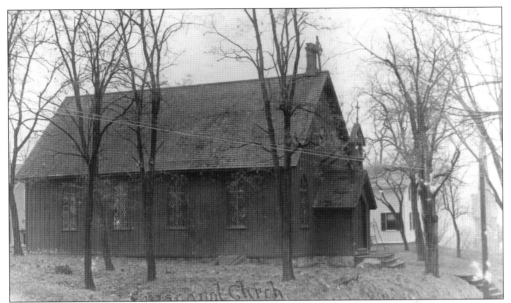

The Episcopal Church was first organized in 1871. Initially services were held in a schoolhouse in Bloomfield. A church building was erected in 1872 on the crest of Church Street (called Piety Hill before the incorporation of the village) above Andrews Street in the village. Services began at the site of the Church of the Good Shepherd on February 6, 1873, with Bishop Coxe officiating. By the beginning of the 20th century, the congregation was dwindling, and eventually in 1929, the vacant building was sold by the Charles Brown family.

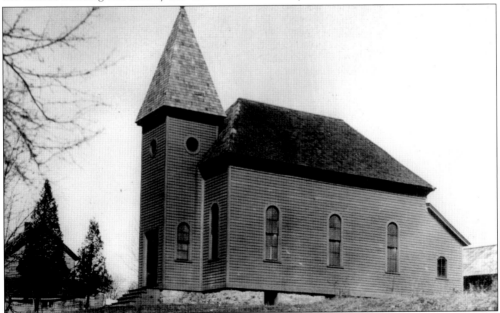

St. John's Lutheran Church, the German Church, was built on Andrews Street. The first congregational meeting was at the Nemitz home on January 4, 1900. The church was dedicated on October 29, 1901, with Pastor Ernest Reissig officiating. Services were given in German and in English. When the church became too small for the Lutherans, it was bought by the Church of Christ in 1966.

Ladies of the Methodist Church are shown here. From right to left are Mrs. Ellis Boughton, Mrs. A. M. Mead, Mrs. Frank Gallup, Etta Boughton, Mrs. W. B. Gallup, Alma Boughton Woolsey, Mrs. Frank Hawkins, Mrs. Charles Bowerman, Marie Horton, Amelia Aldridge, Dora Mead, Luella Boughton, Carrie Aldridge, Mrs. Herman Boughton, and Bertha Bowerman.

The village clock was purchased in 1849 by A. P. Dickinson. It was first placed in the Proprietor's Church on Webster Heights in 1850 and remained there until the church was demolished about 1857. The Presbyterian church became the recipient of the village clock in 1860.

Six

SCHOOL DAYS

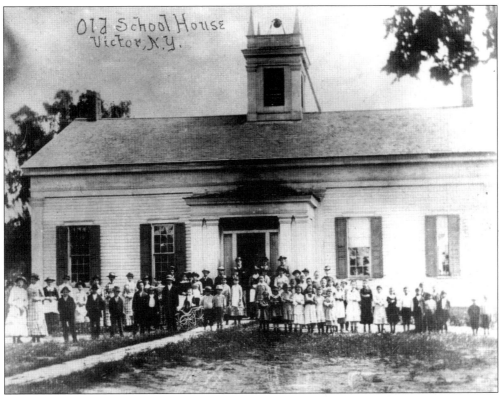

The village of Victor's schoolhouse, shaded by two large elm trees, was erected in 1846 on School Street behind the current location of Canandaigua National Bank. It replaced a smaller cobblestone school building. Gideon Shaw and Orin Preston built the new three-room frame building for $1,153. An extension with more classroom space was added in 1869.

One of the 14 one-room schoolhouses in Victor before centralization in 1939 was the Rice School on the Victor-Holcomb Road. Shown here is a class picture. (Photograph by R. W. Cunnison, Canandaigua.)

The North School, also known as the Hart Schoolhouse, stands on the corner of Gillis and Victor-Egypt Roads. It was built sometime before 1800 for Triphina Hart by her father, Jabez Hart, who built the oldest-documented house in Victor across the street from the schoolhouse in 1803. This is a class picture of 1910–1911.

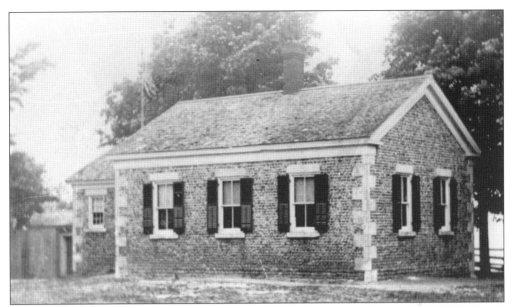

The Cobblestone School was built in 1845. With its school bell, the District No. 7 School, as it was also called, is on High Street Extension. It is noted for its unique cobblestone privy, which had a separate door for girls and another for boys.

The privy at the District No. 7 Cobblestone School is still on the grounds of the old schoolhouse.

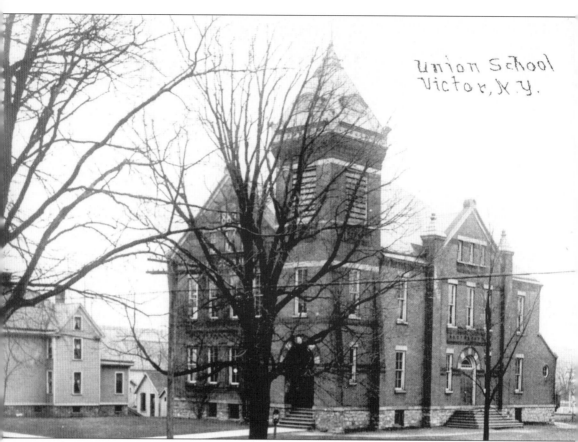

The two-story brick schoolhouse was built in 1884 on the corner of School and Main Streets. Sylvester Wilcox of Honeoye Falls built the school building for $10,225. The architects were Putnam and Block of Rochester. Any town child, after completing grade eight in a one-room schoolhouse, could attend the high school in the village. The first graduation was on June 21, 1884, with 11 graduates. Victor High School was later called Union High School. In 1911, a two-story brick addition was built. The building was vacated in 1941, when a centralized building was constructed on the campus at the former Ladd Farm on High Street. In 1971, the building was torn down to make way for the Canandaigua National Bank.

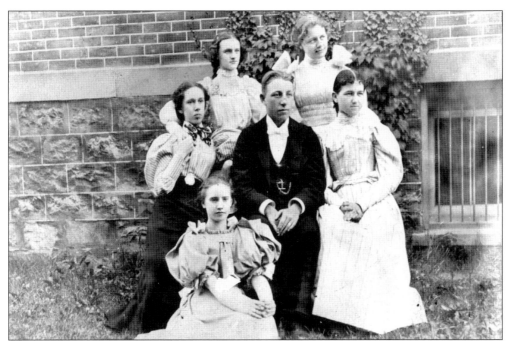

Members of the Victor High School class of 1896 are, from left to right, as follows: (first row) Daisy Tomelenson; (second row) Florence Booth, William Roy Strong, and Cassie O'Neill Malone; (third row) Marion Lobdell and Hebe Berry Bradstreet.

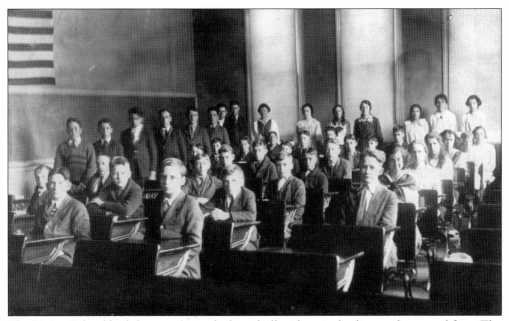

The Union School had three rooms and a large hall with stairs leading to the second floor. The first floor held grades one to seven for the village children. The second floor held grade eight and the high school. Most of the village pupils went home for lunch. The others ate lunch outside or in their rooms. No school buses took children to school then. Everyone either walked or came by horse and carriage or cutter. This photograph shows a typical class of the Union School.

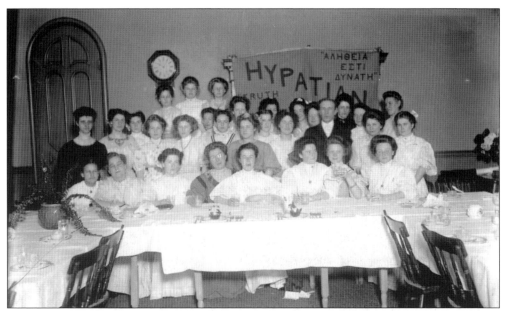

Hypatian was a high school girls debating club that was active in the early 1900s. Members included Rena Dillingham, Ruth Boughton, Maryett Benson, Ruth Hill, Marie Norton, Mary Webster, Ruth Thornton, Elizabeth Osborne, Miss Clements, Miss Jones, Lucy Reissig, Mary Dunlap, Miss Gratrick, Bernice Loney, Helen Smith, Pearl Holcomb, Lottie Rugg, Lucille Simonds, Evelyn Mead, Pauline Wallace, Eugene Powell, Mamie Reissig, Edna Hunt, Helen Ketchum, Hazel Dillingham, Helen Ryan (teacher) Grace Watkins, Belle Barry, Hazel Struble, and Irene Connell.

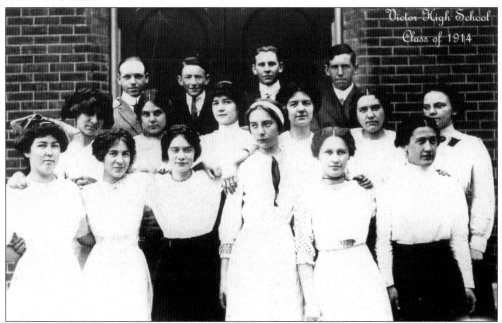

The Victor High School class of 1914 included, from left to right, the following: (second row) Laurette Concannon, Luella Boughton, Lettie Blazey, Bertha Miller, Arlene Gourley, and Lucy Hollingsworth; (third row) Harley Lovejoy, Tom Culhane, Otis Webster, and Charles McCarthy.

Vera Brown, a teacher in Victor for over 50 years, is shown with her class in front of the Victor Union School. From left to right are as follows: (first row) Joe Fort, Sherman Hunt, Orville English, Maxine Sale, Gwendolyn Lamphear, Doris Concannon, Kathryn Hall, Bertha Schooley, Neola Green, and Alice Hughes; (second row) Raymond Rhode, Sherm Cotton, Chas Rhode, Ken Crowley, and Glen Aldridge; (third row) Esther Murphy, Ruth Keefe, Thos Cochrane, Vera Brown, Orlando Pittinger, and Bob Hall.

Vera Brown stands with her horse, Old Gray.

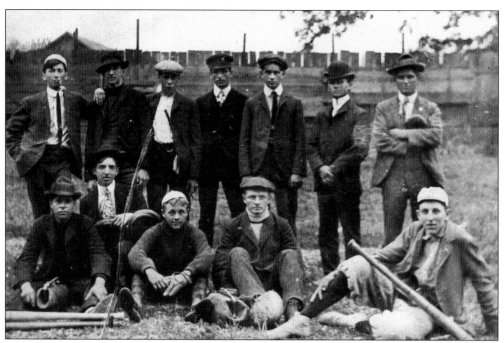

The 1903 baseball team of the Victor High School is seen here with the following documented players: Carl Fairbanks, J. Tischer, Warren Simonds, Bush Osborne, Henry Osborne, H. Herendeen, and A. Hodge.

The ball diamond for the town and for Victor High School was located between Maple Avenue and School Street.

Seven

TRANSPORTATION

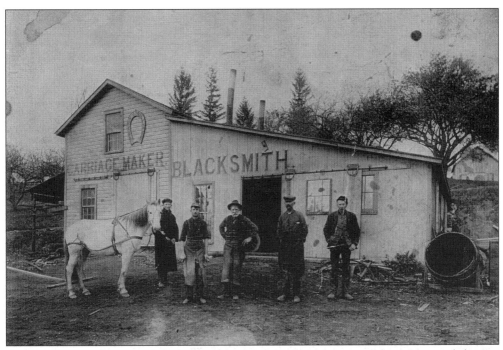

Frank Williams, right, was the owner of this blacksmith and carriage shop. Seen with him in 1902 are Ted McMahon, Tom McKay, and Mose Boltwood. Ironically, Williams was the first person in Victor to own an automobile—a 1902 Packard.

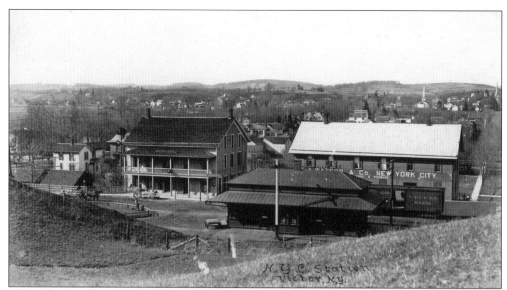

The New York Central and Hudson River Railroad depot is shown here with the Benson House Hotel and T. A. Watson Produce warehouse at the south end of Maple Avenue. The New York Central incorporated Victor's first railroad, the Rochester and Auburn Line, as well as other independent lines by the 1850s. The Benson House was built in 1869 by Chauncey Felt and had been called the Aldrich House, Covill House, and later the Insulator Hotel. The Locke Insulator Hotel could accommodate as many as 60 men employed at the insulator plant, the Victor Flour Mill, or the railroad. T. A. Watson was a New York City produce dealer.

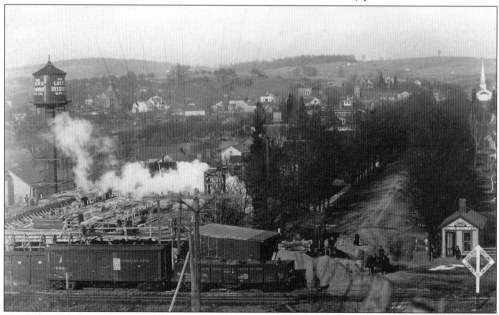

The New York Central Railroad at Locke Insulator, crossing Maple Avenue, shows Loomis and Woodworth, produce dealers, and the "skyline of Victor." Leslie George Loomis first became a produce dealer with W. C. Woodworth in 1882. A large, brick warehouse was located near the Lehigh Valley tracks on School Street. Fishers' potatoes and other produce were shipped from Victor to all over the country.

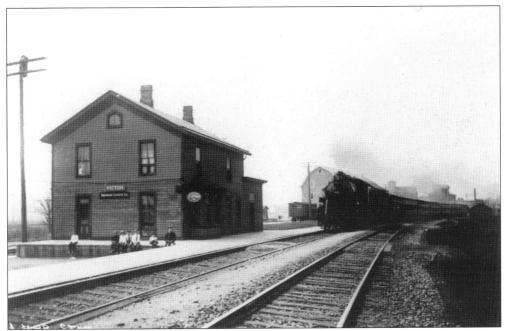

Victor received another railroad going through the heart of the village when the Lehigh Valley Railroad began running freight and passenger service in the early 1890s. The photograph shows the Lehigh's station on Maple Avenue. Its route came from northeastern Pennsylvania and took a more westerly route to Buffalo than the New York Central.

"Petty" Bert and a Mr. McCall pose at the Lehigh Valley Station office.

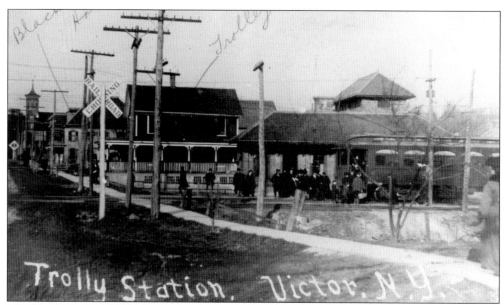

The Black Diamond Hotel was named after the Lehigh Valley's superior Black Diamond train that crossed Maple Avenue by the hotel. In 1898, the Black Diamond Hotel was owned by Mr. Lovejoy and was operated by several individuals until 1914. At that time, James Antonio purchased the building and operated a rooming house and store. It was also called the Trolley Inn because of the close proximity to the Rochester and Eastern Rapid Railway, a trolley that ran between Rochester and Geneva.

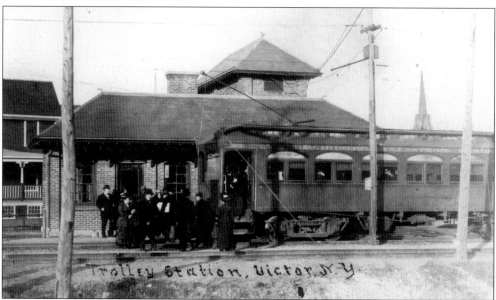

The Rochester and Eastern Rapid Railway arrived in Victor in 1903. A trial run was made from Canandaigua to Victor on Sunday, April 4, 1903, with regular service starting in November. The trolley station and ticket office was located on Maple Avenue, next to St. Patrick's Catholic Church. Some sample rates were Rochester to Victor, 45¢ round-trip, and Victor to Canandaigua, 25¢ round-trip. Because of financial difficulties, the trolley's last day of service was July 31, 1930.

Spring rains make School Street very muddy at the crossing of the Rochester and Eastern Rapid Railway.

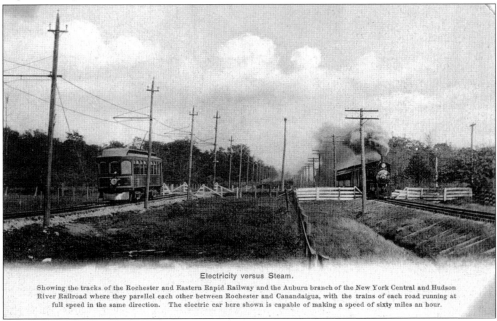

Electricity versus Steam.

Showing the tracks of the Rochester and Eastern Rapid Railway and the Auburn branch of the New York Central and Hudson River Railroad where they parallel each other between Rochester and Canandaigua, with the trains of each road running at full speed in the same direction. The electric car here shown is capable of making a speed of sixty miles an hour.

The tracks of the Rochester and Eastern Rapid Railway and the Auburn branch of the New York Central and Hudson River Railroad at one point paralleled each other between Rochester and Canandaigua. The electric car shown is capable of achieving a speed of 60 miles an hour. A race was set between a passenger car on the New York Central and an interurban electric car of the Rochester and Eastern Rapid Railway. The electric car won.

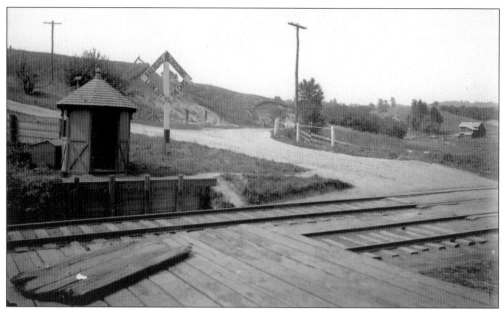

In the early 1900s, the New York Central Railroad put up a sign at the Maple Avenue and Dryer Road intersection. It warned, "Railroad crossing, look out for the cars." As automobiles became more common, other signs and warnings became more widespread.

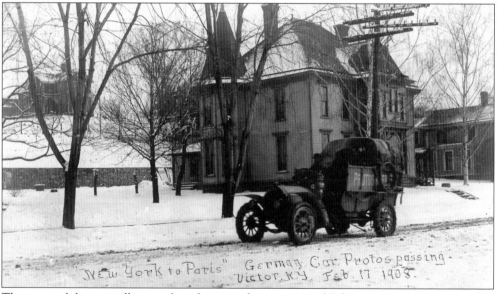

The automobile was still a novelty when, on the morning of February 12, 1908, six cars left Times Square in New York City to begin the greatest automobile race of all time, the race from New York to Paris. Of the six cars that started, one was the 40-horsepower German Protos. It was fitted with a body that was 80 inches wide, sufficient to crosswise sleep an off-duty member of the three-man crew. It also had seven fuel tanks for a total capacity of 176 gallons. When roads were primitive and often nonexistent, this race was difficult—especially in the winter when the route was covered with snow. The total distance was about 23,000 miles—over 13,000 of which was on land. The Protos arrived in Paris first, on July 26, 1908. The Protos went through Victor on February 17, 1908.

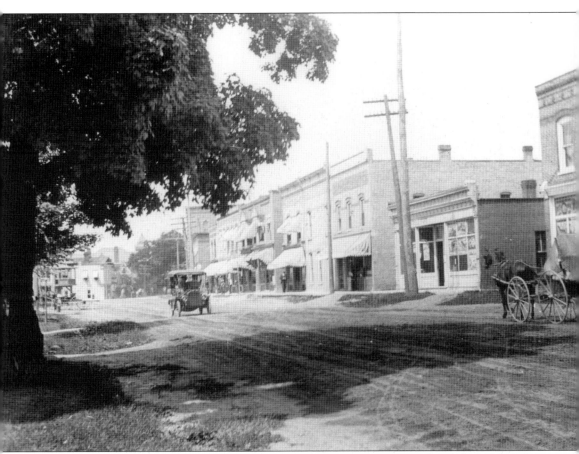

This picture of a motorcar and a horse and buggy on Main Street in 1910 shows the old and the new coming together. Horse-drawn buggies and dirt roads soon gave way to paved roads and automobiles. The first speed limit ordinance was enacted in 1922, with the maximum rate of speed for a motorcar being 15 miles per hour.

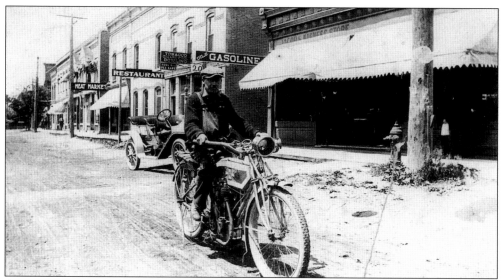

A man on a motorcycle with an automobile in the background on East Main Street depicts the beginning of the country's change to motor-powered machinery at the beginning of the 20th century. A stoplight was first installed at the intersection of Main Street and Maple Avenue in 1927.

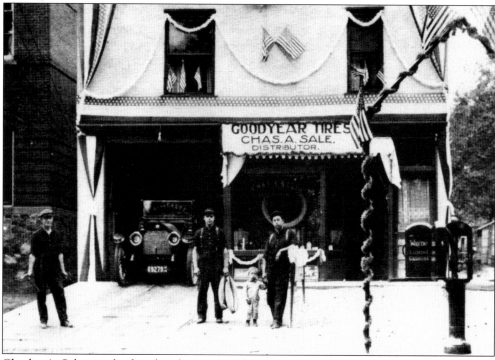

Charles A. Sale was the first distributor of Ford cars in Victor, opening his garage in 1908 next to the east side of the Victor Town Hall. The garage opened only three years after the first Fords appeared on the road. The Victor agency was the third to be granted a Ford agency in Ontario County. In 1920, Fred Sale went into business with him. The company changed its dealership to selling Chevrolets in 1926.

Eight

THE HAMLET OF FISHERS

The Fisher Homestead, on Main Street in Fishers, was built in 1811 by Charles Fisher. Fisher had a sawmill in Fishers and sold land in Fishers to the Auburn and Rochester Railroad in 1837. He became the Fishers station agent. Some windowpanes in the Fisher home are original panes put in by Brigham Young—head of the Mormon Church and architect of the Mormon colony in Utah. The Fishers Post Office was housed in one room of this home when it was established in 1851. Over the years, the dining room served as a meeting place for Mormons and the New York Home Defense Unit of the National Guard. Members of the Fisher family have lived in the home ever since it was built.

The log cabin in the cedar swamp on Benson Road in Fishers was built about 1803. No one knows who built the cabin, but it is documented that Ebenezer Spring lived there in 1803, Hervey Boughton next, and John Rose in 1806. Rose, a circuit Methodist minister, was one of the men who organized the Methodist Church in Victor in 1807. The first public road, Benson Road, was built in front of this log cabin in 1812. The cabin no longer exists.

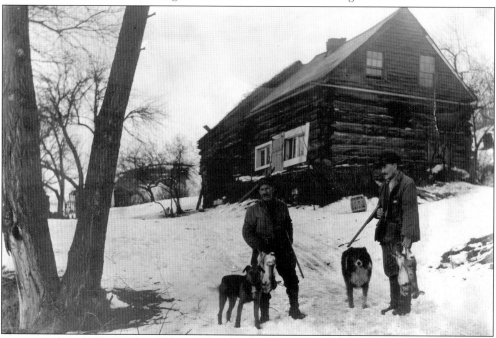

Jim Riley (also called James O'Rourke) and "General" Ulysses Grant Hunt stand outside the log cabin on Benson Road about 1912. The Rochester and Eastern Rapid Railway, a trolley, went past the cabin between 1903 and 1930. A trolley station was even maintained opposite the cabin and was known as Sullivans. The assessment record of 1969 states the following about the log cabin: "18 feet by 48 feet of this house is original log house and very appealing, but a man 5 foot, 10 inches or over could not walk in it."

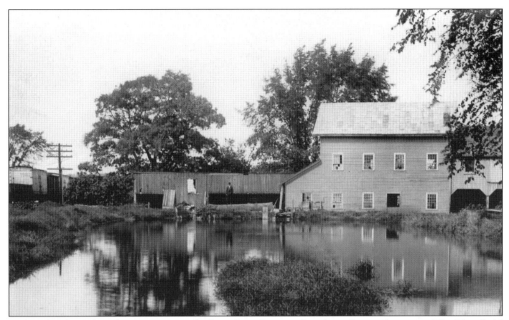

Fishers had an abundant water supply from Irondequoit Creek and its tributaries. The Fairchild River, which flows underground through Fishers, provided springs with an ample water supply. This building was a flour mill in the central part and a sawmill at the left. The mill was built in 1797 by Jonas Allen and was moved to Fishers in 1861 by Charles Fisher. It was later sold to Kingsley Brownell.

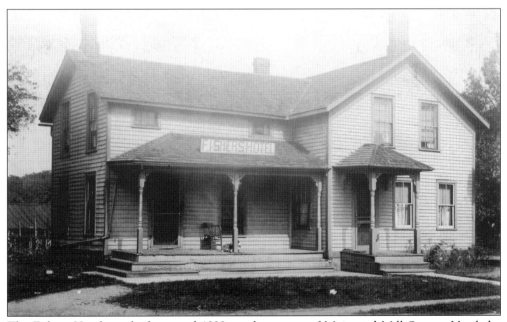

The Fishers Hotel was built around 1838 on the corner of Main and Mill Streets. Until the 1930s, it served as a resting place for travelers of the nearby railroad and for train crews who stopped for dinner. Past owners of the house say that they have experienced unusual "ghostly" events while living there.

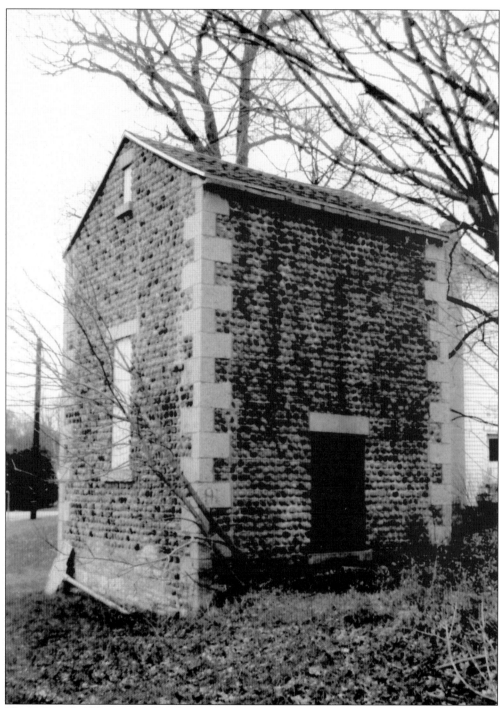

The Fishers Cobblestone Railroad Pumphouse was built in 1845 for the Auburn and Rochester Railroad. It is believed to be the second-oldest surviving railroad structure in the country. The pump house's purpose was to house pumping equipment that fed stream water into a water storage tower to supply water for the steam locomotives. The structure on Main Street, Fishers, next to the firehouse, is listed in the National and State Registers of Historic Places.

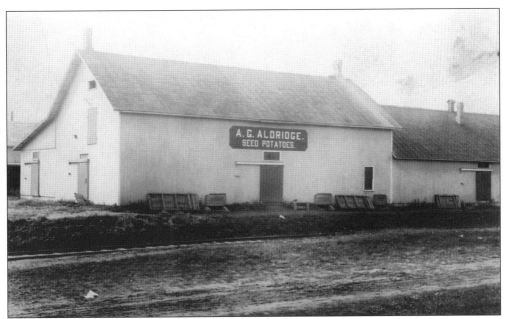

A. G. Aldridge Seed Potatoes warehouse is shown in this photograph. Seed potatoes were grown very successfully in the sandy soils of Fishers. A. G. Aldridge, at one time, raised a monstrous potato the size of a watermelon and it was said to be the world's largest. His warehouse held over 50,000 bushels of potatoes, and he sent seed catalogs all over the world.

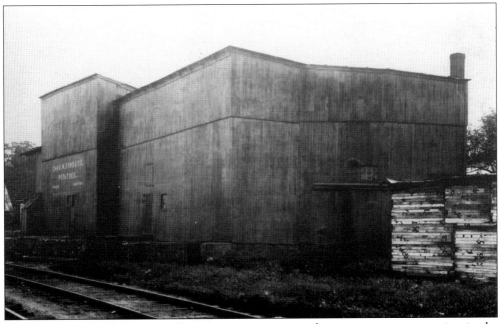

Charles W. Ford and Company, Potatoes, was a major seed potato company operating in the 1870s and 1880s in Fishers. Charles Ford was sent to the Farmers Alliance Convention in New Jersey in 1877 by the Victor Grange. He showed growers the resilient tubers that he grew in Fishers. That one convention proved the high quality of his seed potatoes, and he sent seed potatoes to New Jersey for the next 50 years.

Sarah Murphy Connelly was a big potato dealer who developed a potato that she named after her sister, the Maggie Murphy. In the late 1800s, Sarah Connelly continued the potato business after her husband's death. It was known as S. J. Connelly so that no one would know that she was a woman in business. She was also the Fishers postmistress from 1892 to 1896.

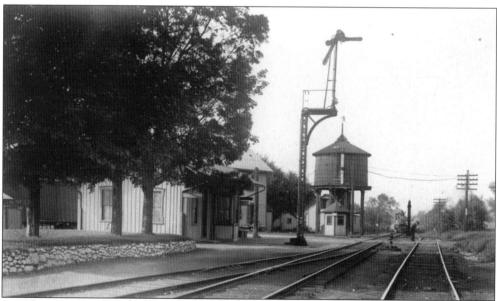

The New York Central Railroad went through the hamlet of Fishers in the mid-19th century. The crossing on Main Street also shows the passenger depot on the left. Charles Fisher, because of the location of his sawmill in Fishers, was able to negotiate a contract to cut ties and lumber for the railroad. At his own expense, he built a station building and undermined Charles Talmadge's quest to get a station near his home on Phillips Road. Fisher also became the station agent for many years.

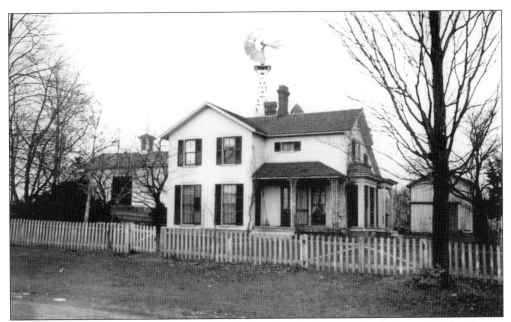

The George Washington Hill House on Main Street in Fishers was built about 1868 by George Washington Hill, son of Gregory Hill. Susan B. Anthony was a houseguest here after a lively neighborhood meeting before her trial in Canandaigua. Arrested for registering to vote in Rochester in 1872, she was tried for this crime in 1873 and was found guilty. Although she was supposed to pay a fine, she never did.

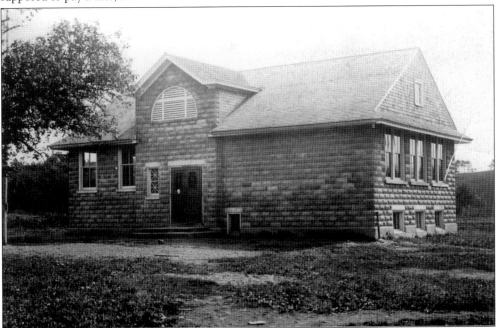

The Fishers School on Wangum Road was built in 1910 by Charles Longyear. Longyear also supervised the building of the original Victor Fire Hall on West Main Street in the village of Victor. On May 26, 1873, Susan B. Anthony spoke at the Fishers School shortly after her arrest for registering to vote in a presidential election and her subsequent trial in Canandaigua.

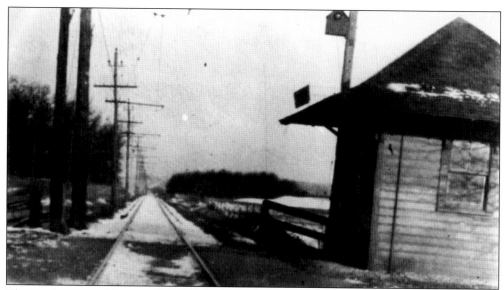

The Rochester and Eastern Rapid Railway Trolley had a station in Fishers. The trolley line was about a mile north of the Auburn branch of the New York Central, in keeping with its intention to keep the trolley line as straight as possible. The trolley ran from Rochester to Geneva with stops in the town of Victor, in East Victor, the village of Victor on Maple Avenue, School Street and East Main Street, and in the hamlet of Fishers at shelters at the Crossman's, Sullivan's, and Wood's properties. Service started in 1903 but, with the invention of the automobile, ended in 1930.

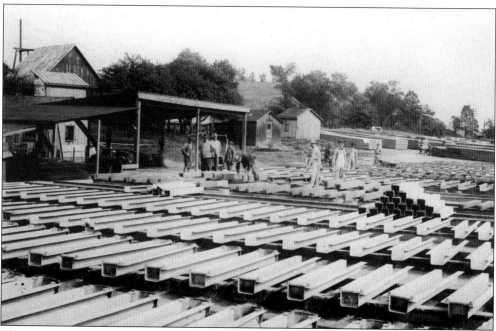

The Concrete Guardrail Company opened on Fowler Street in Fishers in 1910 and manufactured highway guardrails for the many new roadways being built. Reinforced concrete was more economical for road building than wood was, as concrete did not rot or have to be painted or aligned. The plant closed in 1918 because shipping became expensive.

Nine

FRED LOCKE—INVENTOR, INDUSTRIALIST, PHOTOGRAPHER

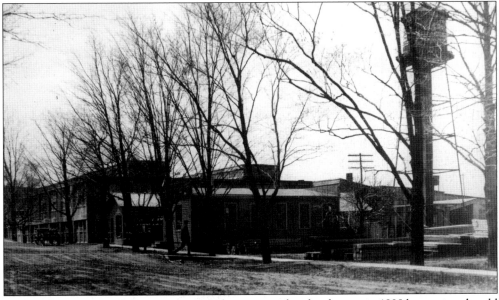

Fred Locke, inventor of the porcelain insulator, opened up his factory in 1898 by renting the old Conover and Shanks sawmill and lumberyard across Maple Avenue from the New York Central Station. Formerly employed as a station agent for the New York Central and Hudson Railroad, Locke invented porcelain insulators because when he was the telegraph operator his messages sometimes did not go through on rainy days. His supervisors thought he was sleeping on the job. His porcelain insulator decreased the leaking of electricity during wet weather.

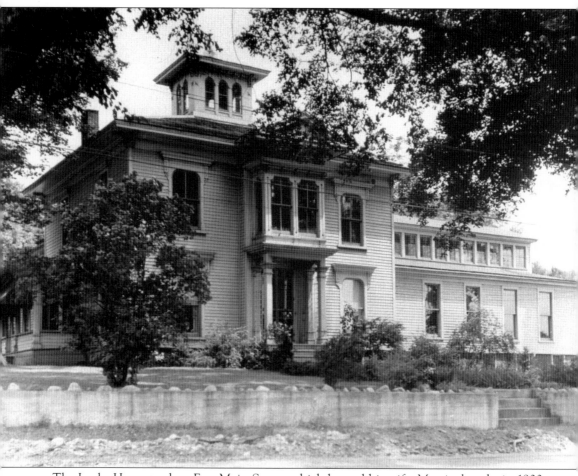

The Locke Homestead on East Main Street, which he and his wife, Mercie, bought in 1900, was where Fred Locke did much of his experimenting. The house had 14 Victorian-style rooms—enough room to raise their five boys, Morton Field, Louis Peer, Fred James, Peer Andrew, and James Lorenzo Locke. After Fred retired in 1904, he decided to add a laboratory to his home, which he did in 1905. The homestead was owned by the Locke family until 1953. It was demolished in 1964 to make room for the new East Victor bridge approach and the widening of Main Street.

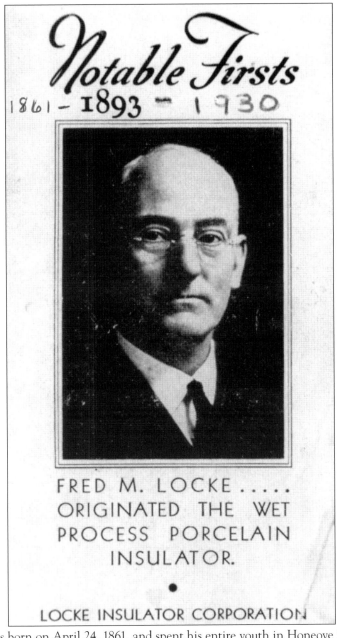

Notable Firsts

1861 – 1893 – 1930

FRED M. LOCKE.....
ORIGINATED THE WET
PROCESS PORCELAIN
INSULATOR.

•

LOCKE INSULATOR CORPORATION

Fred Locke was born on April 24, 1861, and spent his entire youth in Honeoye Falls. Not going past eighth grade, Locke was an inquisitive young man who admired inventors. His father was a telegrapher and station agent for the New York Central Railroad. Locke followed in his father's footsteps and had a career as a telegraph operator from 1880 to about 1887, a station agent in 1887, and then a ticket agent in Victor in 1888. On several occasions early in his career as a telegrapher, he discovered that when the glass insulators were wet, the electrical current shorted out. He experimented and found that by increasing the number of petticoats and making the insulators wider, electrical leakage was reduced. Locke and John Lapp applied for Locke's first patent on October 8, 1888, and it was granted on May 7, 1889. Locke is known as "the Father of the Porcelain Insulator."

Locke Insulator grew rapidly, but in 1900, the factory at the New York Central Railroad crossing on Maple Avenue was ruined by fire. The office was saved, and the factory was rebuilt. In 1902, it was incorporated as Locke Insulator Manufacturing Company. A c. 1902 newspaper article notes, "The Locke Insulator Works of Victor are running night and day at the present time, in order to keep up with the increasing demand for their products. Larger shipments are being made to nearly every civilized country on the globe, and of the foreign demand, that from Italy is especially large."

Originally a lanternslide, this photograph shows a man standing beside a pile of insulators next to a storage building around 1904. Fred Locke first used red clays from the Victor area to make insulators, and William F. Fisher of Fishers is believed to have given him all the clay he desired. In one of the wagonloads of clay, Fisher found a stone with the inscription "PABOS I.Y.I.M. June 10 1618." Sheldon Fisher, a local historian, learned that Pabos was a Basque explorer from Spain.

This is an early view of the Locke Insulator plant. At the beginning of the 20th century, Locke Insulator claimed that it was the largest porcelain insulator company in the world. Fred Locke retired from Locke Insulator in 1904 at the age of 41 because of a dispute with new investors and his refusal to turn over some patent rights.

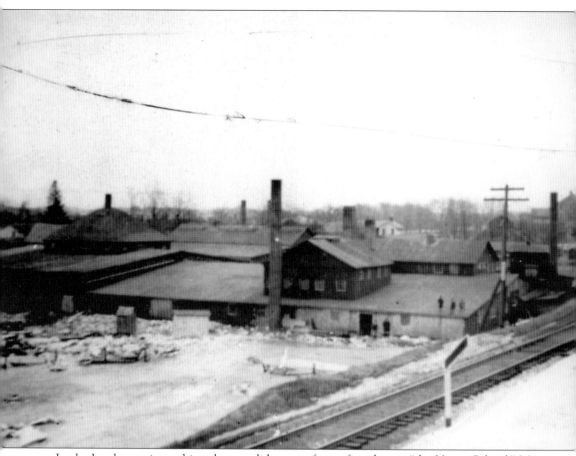

Locke Insulator, pictured in a lanternslide, was often referred to as "the Victor School." Many people came to be trained about insulators in preparation for starting their own companies or working for other companies. In 1904, there were 140 men employed by Locke Insulator.

In an office of Locke Insulator in 1904, a man holds one of the insulators made in the plant.

Fred Locke was an amateur photographer. He developed this interest after he retired in 1904—at a time when Eastman Kodak Company was making film for the ordinary individual. The Osborne House on Maple Avenue was photographed by Locke. Notice the cornstalks and pumpkins in the field in the foreground.

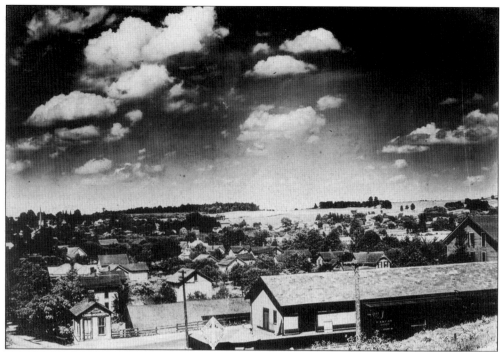

A favorite subject that Fred Locke liked to photograph was clouds, as seen here showing the New York Central and Hudson Railroad Depot.

Original Lehigh Valley Bridge and Fish Creek Bridge east of Victor is seen here as photographed by Fred Locke between 1890 and 1910.

Powell Cider Mill on the corner of School Street and Dryer Road stacked barrels in piles. The barns can also be seen in this photograph by Fred Locke.

General landscape scenes and farmland were prevalent vistas as Fred Locke photographed the countryside of Victor.

An early photograph by Fred Locke is of the village of Victor and surrounding farmland. All of the photographs were developed by Locke in a darkroom in his home.

With clouds as a continuous photographic theme, Fred Locke took this photograph of clouds over the fields of Victor in 1907.

Typical of Fred Locke's photography is this picture of clouds somewhere in the countryside of Victor with an unidentifiable house with curving tracks going by it.

No one knows why Fred Locke was fascinated with clouds, but his pictures are distinct and some of his images were copyrighted in 1906 and marketed.

ACROSS AMERICA, PEOPLE ARE DISCOVERING SOMETHING WONDERFUL. *THEIR HERITAGE.*

Arcadia Publishing is the leading local history publisher in the United States. With more than 3,000 titles in print and hundreds of new titles released every year, Arcadia has extensive specialized experience chronicling the history of communities and celebrating America's hidden stories, bringing to life the people, places, and events from the past. To discover the history of other communities across the nation, please visit:

www.arcadiapublishing.com

Customized search tools allow you to find regional history books about the town where you grew up, the cities where your friends and family live, the town where your parents met, or even that retirement spot you've been dreaming about.